# Mastering Digital Photography:

*Jason Youn's Essential Guide to Understanding The Art & Science of Aperture, Shutter, Exposure, Light, & Composition*

*For my girls **Kristan, Elle & Juliet**.*

# Jason Youn

*First Edition*

**ISBN-13:**
**978-1490475295**

**ISBN-10:**
**149047529X**

For licensing and reproduction permission contact information visit www.JasonYoun.com. For academic use bulk pricing is available.

Author: Jason Youn
Editor: Ramona Howard

# Table of Contents

`~`~`~`~`~`~`~`~`~`~`~`

*Chapter 1*

# Introduction

Photography is something to be loved, explored, learned, and practiced. One summer in the late 1980's when I was still just a kid, our family was off to see the Grand Canyon. As we prepared to embark on our road trip, my dad purchased a pair of matching cheap plastic 110 format point and shoot cameras, one for my brother Andrew and the other for me. We would spend hours of our trip taking pictures of just about anything. It's a wonder that there was even film left to be shot in our cameras after the half day trip to America's great natural wonder. By the time we arrived, we had discovered that our favorite game was to see if we could make a photograph of each other at the exact same moment so that we could capture the other camera's flash on film. This effort did not produce the magical effect we had in mind. Actually, it proved itself impossible, and we ended up with several spent rolls of really awful images. From looking over our developed photographs, you would never guess that we actually went to the Grand Canyon. For the most part, our photos were of the inside of pockets, a random squirrel as it ran past, or each other as we worked for our illusive simultaneous flash shot. As the years passed, I continued to waste time and film making really bad photographs; each one seemed worse than the one before, but it was still fun, and I was still shooting.

Soon I would discover the moving picture. With my parents' old Hi8 camera in hand, my friends and I set out to create a cinematic reproduction of Jules Verne's, *A Journey to the Center of the Earth*. After hours of work, a few pounds of gunpowder extracted from a model rocket kit, and the occasional feeling of panic as we searched for the fire extinguisher, our film was done. Once again, our special effects would not make up for bad camera work. The project was shelved and never seen again.

In high school I began taking photography classes. This time I had with me a Single Lens Reflex Camera (SLR) that shot 35mm film. The instructor tried to teach her pupils the finer points of black and white photography, but it was not the breakthrough I was looking for. A major problem for me was the textbooks, filled with complex information and arranged in a way

that made little sense. They proved to be more infuriating than informative, and at 300+ pages, they were too long to be useful to a beginner, or probably anyone for that matter. Although that class and textbook nearly killed it, my love of photography and cinematography remained strong and I sought richer waters.

Luckily college offered me an ocean. I attended film school specifically to learn how to become the next Tim Burton. Though I studied motion picture, script writing, cinematography, and lighting, my experiences expanded beyond the motion picture and I learned more about still photography at that school than at any other single place. The complexities of it all began to fit together. The relationships between ISO, aperture, shutter speed, and lighting came into focus -- and so did my images.

After a short career in television, I decided I loved the craft, but the industry was not for me and I went back to school to earn a degree in Art History with a minor in Religious Studies from ASU. I kept working with still photography.

Soon my work got some attention, won some awards, and people began to hire me to do everything from weddings and portraits, to sports, catalogues, school photos, and product shots. I began doing art shows and selling my landscape work; over time my skill grew right along side my business. The more I shot, the more people kept asking for advice with photography.

I found that I was good at instructing people on how to use their own cameras. All those numbers, dials, buttons, and settings mean something, and if you learn how and why to use them, you will be a better photographer. Beyond that my BA in Art History has shown me that there are some simple rules of art and design that humanity has spent the last 3,000 years or so mastering. In the later parts of this book I'll use both text and images to show you what they are, and when to use them. Keep them in your mind as you shoot.

I created this book because I want you to go from just taking pictures to creating photographs. Anyone can learn how to create beautiful images and you don't need an expensive camera to do so, but you do need just a little bit of information and a good deal of practice. While you read this book, keep your camera and your camera's photo manual near by. Highlight the portions you want to remember and refer back to them often. Try working with the camera's settings as you go. See what works and what doesn't. If you are the log book or journaling type, buy a blank page book just for photography and keep a record of your actions, camera settings, environment, and the resulting photographs. Don't be afraid to jump right in and try experimenting; sometimes the best photos happen completely accidentally.

# The Camera

From DSLRs to Camera Phones, Water Proof to Infrared, there are more camera types out there than ever before. Making the right choice when buying a camera can seem daunting and difficult. You don't want to spend too much money, but you don't want a camera that will underperform either. I have been asked time and again for advice on what camera to buy and I almost always answer with a question, "What do you plan to use your camera for?" Some cameras, usually the expensive ones, will allow you to make virtually unlimited changes to the settings and the way the camera captures an image; others have little more than a few auto exposure modes and button on top. Size and weight, durability, functionality, quality, and cost all factor in to my answer.

I'm a bit of a camera geek, and I love my high end cameras. On my first photography trip to the wilderness of the far northern portion of Arizona, a seasoned old photographer gave me some advice, "Buy the best camera you can afford." It was obvious that he had taken his own advice. He carried with him two of the highest end SLR 35mm film cameras made, each with top quality lenses, while I carried a mid-grade 35mm with a mid-grade lens, which at the time, was all I could afford. There was some wisdom in his advice, and his photos gathered from around the world were beautiful and very well crafted, and while $9,000 strapped to your shoulder can help, nothing can replace good camera work and the skillful application of the rules of art. Without those, even the world's best camera will not create a great photograph. Because of this, the best camera to use may just be one that you already have handy. If you understand the rules of photography and art, a small point and shoot, or even a camera phone can make a striking image that will have an impact on your audience.

The photography book *The Best Camera Is The One That's With You,* by the established commercial photographer Chase Jarvis, is a 250 page collection where every photo was taken by Chase on an old low quality iPhone. While Jarvis could have used any camera he wanted, he chose the relatively low quality but ubiquitous iPhone to make his point that you don't need the best to create a great image.

I have spent my life looking for simple ways to make a great photograph, and burned through miles of film wondering why my images looked bad. After years of trying I finally had some breakthroughs in film school. I wanted to make movies, and the principles of the image that I learned in film school showed me how to create beautiful still photographs. It just takes a few bits of information to get going in right direction. It does not matter if you are shooting still or motion, DSLR, or just a camera phone. By the end of this book your photographs will look better.

# Common Types of Cameras

Though there are literally hundreds of camera types out there, you will probably find only a few at your local store. These next few are the types you and I are most likely to use.

### Point and Shoot Cameras

As the name suggests a point and shoot camera is just that. To operate it you simply turn it on, aim, and fire. In a snap, you have made a picture. Though most of my work is shot with a DSLR, I still keep a Point and Shoot handy. They make great "walking around cameras" and with a few tips and tricks you can actually make a great photograph with these small cameras, or even your camera phone. Their small size makes them perfect to toss in a bag or purse. They are relatively cheap, and the quality of the image they make just keeps getting better as new technology makes its way to the market.

### DSLR - "Digital Single Lens Reflex" Cameras

A DSLR camera has a **Digital** image sensor like a CCD or CMOS instead of film. It has a **Single Lens** for light to pass through, either on its way to your eyepiece or your image sensor, and a **Reflex** camera allows the photographer to simultaneously view and focus the image that is about to be captured.

These are the big cameras that you see on the sidelines of a sporting event, or in the hands of a wedding photographer. They do the bulk of the pro-photography work, and they are very

popular among amateurs, enthusiasts, and semi-pro-photographers as well. They can range in price from a few hundred to several thousand dollars. There are many advantages to using a DSLR but the most notable are probably high quality images, complete and accurate control over camera functions and settings, ultrafast response time, and interchangeable lenses. Beyond that, they just look cool.

### Crossover Cameras

Crossovers incorporate a bit of both the point and shoot, and the DSLR world. They are usually priced between a DSLR and a "point and shoot." They are more compact and lightweight than a DSLR, but substantially larger than a point and shoot. They normally have more programmability, better optics, and a better lens than a point and shoot, and usually cost a bit more as well. They lack, however, the interchangeable lenses, quick access to camera settings, and the robust feel of a DSLR. There is also a new line of cameras that I would place in the crossover section making their way to the market called mirrorless interchangeable lens cameras. They are about the size of a point and shoot but can accommodate many of the same lenses that will fit onto a DSLR.

Though much of the first half of this book is geared toward a camera like a DSLR or crossover where you can access priority and manual modes with ease, there is still a lot of information that pertains to all cameras, even a point and shoot or camera phone.

# History

Before all of the great high tech photo gear we have today, there was a simple invention; compared to the tools we have now it is like the tools of a cave man, but for the time it was ground breaking, and the very first cameras date back much farther than you may think.

The word camera comes from the Latin phrase, *Camera Obscura*, meaning "a dark chamber." Add a small hole to that chamber and light can enter into it at one place. To effectively focus the light, a lens is then added over the hole. A camera with this simple construction was mentioned in a book of optics dating back to the early ninth century A.D. Later, in the Renaissance period of Europe, these early cameras were used to help painters see how a 3D world might look when projected on a 2D plane such as a painting. Though camera technology dates back at least 1200 years, it would not be until 1826 that the camera would first record light, a task that our eyes have managed for thousands of years.

Cameras operate like a man-made version of our eye. Light reflected off of objects enters the camera, or our eye, through a small hole with a lens; that light is then focused on the back wall of the camera or eye. A surface that is sensitive to light, and sometimes color, collects and records that image. This image of the outside world is projected upside down in the camera or eye. Our brains then take this upside down information and invert it for us so that we interpret the world with relative accuracy. In a camera we correct for the upside down image by rotating the print.

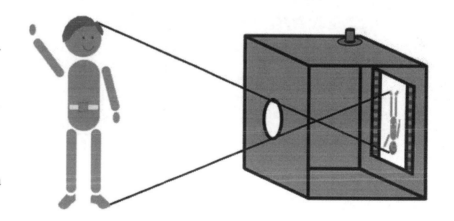

In 1826, Joseph Nicéphore Niépce created the first photograph when he discovered that a mixture of silver and chalk suspended in solution tended to darken on the side of its clear glass container that was exposed to sunlight. He took this solution and coated a piece of bitumen (a rock) and placed that in a *camera obscura*. Over the next eight hours, the camera collected light

and focused that light on the silver coated bitumen. The first photograph, "View from the Window at Le Gras," was created.

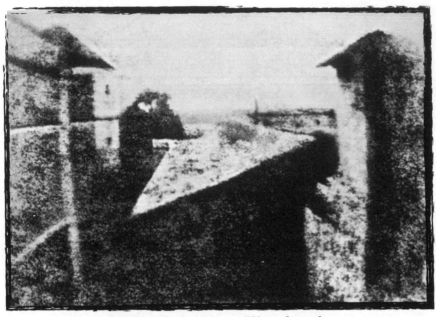

*Joseph Nicéphore Niépce, "View from the Window at Le Gras," Silver on Bitumen - 1826*

Cameras collect and then record light on a light sensitive surface. For nearly 100 years, film was the undisputed king of that world. Recently, however, it has been replaced by digital light collectors like CCD (charge-coupled device) or CMOS (complementary metal-oxide semiconductor) sensors. These new digital image sensors allow freedoms that normal film never could. The power to instantly review our images means that we can learn from our mistakes right away, rather than having to wait for a lab to develop our photographs and then tediously compare those images to our notes. Digital also means that we are no longer paying per image, so we can shoot a lot more without spending a lot more. Also, ditching film means no longer having to work with those toxic lab chemicals. For all their differences, however, the principles of film and digital photography are almost identical, and if you can shoot one, you can shoot the other.

Niepce's early camera had almost no way to control the amount of light it was taking in. He simply opened the shutter, and eight hours later he closed it. Our modern cameras have several ways to control the amount of light they collect and record. This is called exposure control.

# Exposure

All cameras, film, digital, still, or motion picture, have at least one simple thing in common. They all collect light. If you are taking a photograph of an object, the light that a camera collects starts at a light source like the sun or a lightbulb or a flash. The light then bounces off of that object, passes through the camera's lens and is focused onto a surface. If the camera is going to record that light, this surface must be a light sensitive material. Though this light sensitive material can be a number of different things, for most of this book, we will call that material an image sensor; if you are shooting digital, this is what you are using. This includes a DSLR, crossover, point and shoot, and even your camera phone.

Exposure is the amount of light that enters your camera and is collected by the image sensor. Proper exposure happens when enough light hits the image sensor to create an image that has light, dark, and middle tones. Ansel Adams and his friends in the f/64 group used a system of eight black and white zones to evaluate proper exposure. Normally if all eight zones were represented, the image was properly exposed and or properly printed, but those were back in the days of black and white dark room work; today we not only use color, but we have instant, digital color with computerized exposure evaluation. There are now many ways to evaluate proper exposure. Perhaps the most scientific is the histogram and we will go over that in just a few pages. Nothing however can make up for your own personal preferences. In this chapter we will talk about several ways to keep track of and control the exposure in your camera. If you shoot on a camera with full manual mode or priority mode, it will be easy to adjust these settings. In a camera that is mostly automatic, there are still usually some effective options for you to use; they are just a tad bit harder to access.

# Stops

Stops are simply a quick way of measuring amounts of light. Almost everything in photography, from shutter speed to aperture, film speed to lighting, uses this same scale. The scale functions by either halving or doubling the amount of light that makes it to the sensor. If an image is one stop overexposed, that means you have twice the amount of light required to create your image. If an image is one stop underexposed, that means you have half the amount of light required to create your image.

For the math people out there: You may have noticed that a scale based on doubles and halves is not linear like a ruler or measuring tape. Rather, this scale grows at a compounded rate, like 2, 4, 8, 16, 32, 64 and so on. This is because the scale is based on how our eyes perceive light. When there is a little bit of light in the room, our eyes can detect minor changes. When the room is very bright, it will take a much larger change in brightness for us to notice a meaningful difference in lighting. Think of using a flashlight outside on a sunny day. The light makes almost no difference. Use that same light on a moonless night, and the difference in brightness is profound. In both cases the flashlight added the same amount of light but it only effected a major change at night, when it had the ability to more than double the available light. Because of how our eyes, and likewise our cameras, detect changes in light, the scale of stops indicates when the settings on your camera will either double or halve the light it gathers. This way your camera, and our eyes and brain will perceive a linear transition from one level to the next at each "stop" setting.

# TTL

You may choose to shoot with auto exposure or manual exposure. Either way your camera has a built-in light meter that measures the amount of light that is being collected. With this measurement, your camera can either choose the correct camera settings automatically, or if you are not using auto exposure, your camera will inform you that your image is either underexposed (too dark), overexposed (too light), or properly exposed. The light that is measured to allow the camera to come to this conclusion is collected through the lens of your camera, hence the name *Through The Lens* metering or *TTL*. It is then measured inside the body of your camera. There

are several other ways that a camera may measure light for proper exposure, TTL however is the most common method used by modern cameras.

If your camera is set to automatic, metering and exposure are done completely automatically. If your camera is set to manual, you will be able to tell the camera what to do, and your camera will let you know how much light it has via its built-in TTL light meter. It will display this information with a line graph that looks something like the image to the left. Proper exposure will be in the middle of the graph, underexposed will be to the left and overexposed will be to the right. For the details about how this looks on your specific camera, consult your owner's manual; most of the time, these indicators are obvious and can be found both on the camera's LCD screen located by the shutter release button and in the digital readout found inside the reticle or eyepiece at the bottom or to the side of the frame. Here are three examples of how your light meter information may look in a Canon camera. Nikon will look similar; other brands may vary.

Most of the time shooting with auto exposure works great. It's fast, accurate, convenient, and easy to use, but there are some things and situations that can cause even the most advanced camera to become confused and create an image that is not properly exposed.

Your camera's light meter is color blind. TTL metering works by measuring reflected light in levels of black and white and shades of grey. Proper exposure is based off a specific tone on the grey scale, halfway between pure black and pure white, known as middle grey. It just so happens that middle grey absorbs 82% of the light that hits it, and reflects 18%. So you may also hear middle grey referred to as 18% grey. Your camera will try to make the average brightness of your image match this tone. So why pick middle grey, why not some other lighter or darker tone?

All objects absorb some light and reflect some light; the amount of light reflected depends on the color and the object. The amount of light reflected off of a middle gray object is 18%, while 82% of the light is absorbed. In a black and white photograph, a normal blue sky, the green leaves of a tree, and average middle European Anglo-Saxon skin will all look to be just about

middle gray if properly exposed. Color film's exposure levels are the same as B&W. So for most photos, middle grey, green trees, blue skies, and many other common objects, expose perfectly when your camera looks for an average tonality of 18% grey.

When either the subject or background of your photograph are much darker or lighter in real life than middle grey, your camera will become confused and your image will end up either under- or overexposed. For example, if you are photographing a black dog on a dark background, your camera may try to make that black look grey and thus overexpose the shot, or if you are photographing on a bright sunny day on a ski slope surrounded by snow, your camera will expose your image so that the white snow will look middle grey and thus create an image that is underexposed. If this problem is happening, you can easily correct it with the auto exposure bias setting on your camera.

To find out how to adjust this on your specific camera, consult your owner's manual. On my camera, you would press the shutter release button halfway down so the camera can meter the scene. Then you would turn a dial to tell the camera how much you would like it to adjust its auto exposure bias, telling the camera to either over- or underexpose the image to compensate for the environment. For example, if my images are coming out underexposed or too dark by one stop, I will tell my camera to overexpose by one stop to compensate. Likewise, if my images are one stop overexposed or one stop too bright, I will tell my camera to underexpose by one stop. I will cover more about this later in the section for auto exposure bias and lighting.

# Histogram

Exposure is sometimes a matter of opinion. An image may simply just look too dark or light, but there are also some tools in your camera and on your computer that will show you via a type of graph if the image is technically well exposed. If you shoot a digital SLR or a crossover, your camera can usually display a histogram. This histogram works like a bar graph; the dark parts of the image are represented on the left with the light parts on the right. If you have a lot of blacks, there will be a peak on the dark (left) side. If you have a lot of whites, there will be a peak on the light (right) side. Normally, a properly exposed image has a histogram that looks much like a bell curve. If an image is heavy on the left, there is a good chance that it is underexposed, and if it's heavy on the right, there is a good chance that it is overexposed. The histogram works on a scale of 0 to 255; 0 equals black and 255 is equal to white. A histogram is not the end-all-be-all of defining exposure. In the same way the TTL metering can get confused if your image is of a white snow drift or dark subject, your histogram may lean to the left or right if your subject is predominately light or dark. In a typical image however, it can give you a fairly good idea of your level of exposure. The following diagram shows three histograms: under-, well-, and overexposed.

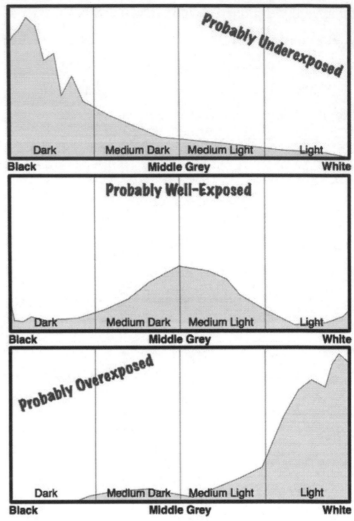

# Controlling Your Exposure

Understanding that an image is over- or underexposed is important, but it's pointless unless you can correct the problem. Thankfully there are four ways to control the exposure of your image: *available light*, *aperture, shutter speed, & ISO*. These next few sections will address each one of these, one at a time. Like so many other things in life, each one of these ways of adjusting exposure has a give and take, and has other effects on your photos beyond just exposure. Deciding when to adjust one over the other will sometimes come down to the limitations of your camera or environment, the desired outcome, or just personal preference.

# Light

In order to make a photograph, you must have photons or light. Available light is light that is either already present -- *ambient* -- or can be added to your environment. You can change your available light in many ways. Opening or closing the mini-blinds or just going from one location to the next works great for affecting the natural light in the room. Artificial lighting, like a lightbulb, or a flash on the camera, will also add light. Too much light will overexpose your image. Too little light will underexpose your image. Some of the later portions of this book go into how to control the light that you have. For the next few sections, let's assume that our available light is a constant that cannot be controlled or changed, and we have plenty of it to work with. Later we will talk about how to control this with flashes, reflectors, and light bulbs.

Once we have enough light to work with, there are then three ways to control your exposure, and all three of them are done right in your camera. Knowing how to control your aperture, shutter speed and ISO, are the foundations for knowing how to take your camera beyond fully automatic mode, and will allow you to get more creative with your photography skills.

# Aperture

The aperture is the adjustable hole in the lens that light must pass through; it can adjust in size from large to small. Much like the human eye has an iris that changes size as the light in the room changes, your camera lens's aperture can change size to accommodate different levels of light. When the hole is large, or wide open, a large amount of light can pass through; when that hole is small, or constricted, only a tiny amount of light can get through. The size of this hole is noted by your camera as a ratio called an f-stop. Remember: Stops work with double or half the amount of light. You may have seen numbers like f/5.6 or f/16. These are the f-stops.

### Basic F-Stops

F-Stops are listed in an order so each stop lets in one half the amount of light as the stop before it. The smaller the number the more light it lets in; the larger the number the less light it lets into your camera to be recorded. They are as follows: f/1, f/1.4, f/2, f/2.8, f/4, f/5.6, f/8, f/11, f/16, f/22, f/32, f/45, f/64 etc.

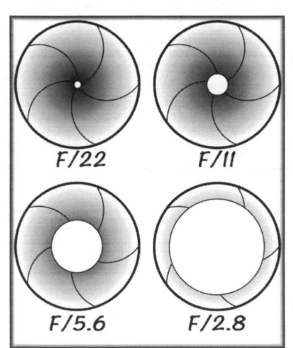

Most camera lenses range from about f/4 to f/22 or so. A nice fast lens can get down to f/1.2 or faster. On the slower side, some cameras, like a pinhole camera for example, operate in the neighborhood of f/144. You may have noticed that your camera has more numbers than ones we listed here. Modern cameras can set the size of the aperture to sizes between stops. This allows for greater accuracy in your exposure.

Some cameras can select apertures in half stop increments; some are more accurate and can select in third stop increments. In a full stop camera, you will go from f/8 to f/11, one full stop. In a half stop camera you will go from f/8 to f/9.5 to f/11. In a third stop camera you will go from f/8 to f/9 to f/10 to f/11. In every case it is just one stop from f/8 to f/11.

Memorizing the common or whole stop f-stops from about f/2.8-f/22 or so may seem like a chore. After all, you got into photography for fun, not to keep track of random numbers, but committing them to memory will help you gain control over the other functions of your camera like shutter speed, and ISO. These three settings are all reciprocals of each other, that is to say they maintain a relationship. This relationship is called reciprocity and is covered later in this chapter.

### Advanced F-Stop Theory

F-stop numbers may seem strange and random. They are not. That odd number is actually a quotient, an answer to a division problem. You will never need to know how an f-stop is calculated to effectively use your aperture or to take a great photograph. Actually, I was a bit rusty on the finer points of how an f-stop is calculated before researching the details of it for this book, and though you will probably never need to know this, for all you serious camera geeks out there, here is the complex nitty gritty on the aperture and the f-stop.

A division problem expresses a relationship between two numbers. We arrive at an f-stop by taking the focal length of the lens that contains the aperture and dividing it by the diameter of the opening of the aperture in millimeters. For example if you have a 50mm lens, and the diameter of the aperture is set to 25mm, your math problem is 50/25=2 and the derived f-stop is f/2. In this case the diameter of the opening of the aperture is ½ as large as the focal length of the lens. If you change that opening and make it smaller you are *stopping down* your lens. This lets less light into your camera. If that opening is just 3.125 mm wide on that same 50mm lens your math problem is now 50/3.125=16, so your lens is set at f/16. The aperture's diameter is 1/16th the size of the focal length of the lens.  If you wanted very fast lens like f/1, on that same 50mm lens we would have this math problem 50/x=1. The solution of course is x=50 and thus the lens would have an aperture diameter of 50mm. Now, in order to take in ½ as much light or to be one stop slower, the *area*, not the diameter of the aperture's opening must be ½ as large (Area=$\pi r^2$). Half the area of that 50mm f/1 opening gives us a diameter of about 35.355mm and 50/35.355 = 1.414, hence f/1.4 lets in ½ the light that f/1 does, and is the next f-stop. This continues from f/1, to 1.4, to 2, to 2.8, to 4, and so on in both directions. There are some lenses out there that are faster than f/1 but they are extremely rare and very expensive and I don't think they are in production at this time. To my knowledge f/1.2 is the fastest lens currently in production.

How an f-stop is calculated explains why a fast lens, or one with a big aperture costs more than a slower one. To illustrate, instead of a 50mm lens, let's use a 100mm lens. If the opening is again 25mm but the lens is now 100mm long, our math is 100/25=4 or f/4. To get a 100mm lens down to f/2, the opening would have to be 50mm wide. This requires a wider aperture, wider, larger glass lenses within the lens itself, a wider tube to house the lenses, and also more powerful motors to move heavier glass back and forth to focus the lens, thus we have a more expensive lens.

If you have been to a pro-sports game you may have noticed some photographers with gigantic lenses. While those pro lenses do have quite a zoom, there is a good chance you have a lens with an even greater zoom right in your camera bag at home, but your lens was probably less than a tenth the price of the big pro-sport photo lenses. Those lenses must be large so that they can accommodate a very large aperture. This way they can be used in low light and still collect enough light to make a useable image. A Canon 800mm f/5.6 needs an aperture that is about 142mm wide, it weighs 10 pounds, is almost 2 feet long, and the price in 2013? This big boy will only set you back about $14,000 USD.

### Using the F-Stops

Understanding how that crazy number called an f-stop is calculated makes it easy to understand why a small number equates to a big hole and a big number equates to a small hole. Knowing that a big hole lets in more light, you can know that you need an open aperture, or small f-stop like f/2.8 in a dimly lit room, and a constricted aperture, or big f-stop like f/16 in a bright sunlight. The more light you have, the smaller the aperture hole you will need. If your photos are underexposed, you can correct this by letting in more light with the aperture; if they are overexposed, you can let in less light with the aperture.

Beyond controlling exposure, aperture is the primary tool that we use to control *depth of field*, or the amount of the image that is in focus. Depth of field and focus are both covered in chapter 4.

The size of the hole that light must pass through is an important tool in controlling your exposure. The next way to control the amount of light your image sensor receives is by controlling how much time your camera spends collecting the light. For this we control exposure using the camera's *shutter speed*.

# Shutter Speed

The shutter on a camera is a sort of light tight sliding door. When it is open, light can pass through it to the image sensor; when it is closed no light can enter and the image sensor is concealed in complete darkness. When you are not taking a picture, the shutter is closed. The moment you fully depress the shutter release button the shutter opens and light can pass through the lens containing the aperture through the open shutter to the image sensor.

The amount of time that your shutter remains open is called the *shutter speed*. The shutter usually remains open for only a fraction of a second, but there are times when you may want to leave your shutter open for much longer. The longer the shutter remains open, the more light can pass through the camera to the sensor and the image sensor is "exposed" to more light. When the shutter is open for a shorter time, less light reaches the image sensor and the sensor receives less "exposure."

Just as with aperture, shutter speed works with halving and doubling. When the aperture changes size, the shutter adjusts the time it remains open. Half the time open = half the light to the sensor or one less stop of exposure; double the time open = double the light to the sensor or one more stop of exposure.

Unlike aperture sizes measured in f-stops however, these times or stops are very simple and straightforward. When your camera tells you that your shutter speed is 200, it is actually telling you that your shutter is open for 1/200th of a second. A one stop faster shutter speed (less light) would be 400, or 1/400th of a second, or half the amount of time as 200. No crazy math problems here, just a real number that indicates time in fractions of a second.

Most DSLR cameras have built in settings that range from 30 seconds to 1/4000th or even 1/8000th of a second. If your camera is set to expose for 1 second or more, the number will have a quotation mark after it. For example, 3" is three seconds where as 3 is 1/3rd of a second. If you want to make a photograph that will take longer than 30" (thirty seconds) you can place your camera in "bulb" mode. The bulb setting allows your cameras shutter to stay open for as long as the shutter release button is depressed. There are also external shutter release buttons that allow you to lock the shutter open indefinitely, or they can have your camera take photos at regular intervals. The bulb setting is great for lightning or astral photography. There will be more information about that in the tips and tricks section of this book.

The shutter speed *stops* that you will work with most of the time are 15, 30, 60, 125, 250, 500, 1000, 2000 and so on. For the most part if you are slower than about 1/60th you will need a tripod, but that's not always the case. There is a neat rule of thumb for this and I'll get to that soon.

Just like with aperture, controlling exposure using your shutter comes down to letting in more or less light. With aperture, however, you are adjusting the size of an opening, with shutter speed you adjust how long the shutter stays open. If you are underexposed by one stop at 200, change to a shutter speed of 100. The shutter will stay open twice as long and the shutter will let in double the light, or one more stop of light, and the exposure will be correct. If you are overexposed by one stop at 200, change to 400 and the shutter will let in half the amount of light, the exposure will then be correct.

The next image is a visual of 5 common shutter speeds and the relative amount of light they let in to your image sensor.

Just as with aperture, your camera may also have options for ½ & ⅓ stop increments. A change from 100 to 200 is a change of one full stop; 100 to 125 is ⅓ of a stop; 125 to 160 is ⅓ of stop and so on; 100 to 150 is ½ of a stop and so on. Many cameras allow you to decide if they operate in full, half, or third stops. On my camera I go to the custom functions and tell the camera how I would like it operate. You may have to check out your owner's manual to see how this is

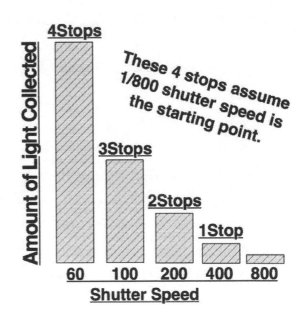

accomplished on yours. I prefer to use my camera with the third stops feature enabled. This affords me just a little more accuracy. I turn the selector wheel one click on my camera and I add or remove one stop, and I now have it set to muscle memory in my index finger, every three clicks of the wheel is one full stop. Changing the shutter speed is a great way to adjust for exposure without having to change the aperture, but there is always a give and take. Shutter speed affects more than just exposure, and the same subject will look different with a slow shutter versus a fast one.

**Motion Blur**

If you have your camera's shutter open for a relatively long time like 1/15th of a second, or 15, you will be able to gather light as a subject is moving. This will create a blurry subject, but is not necessarily a bad thing. Sometimes a bit of blur due to a moving object, often called "motion blur" will make your image look great. Think of a race car, or cyclist flying by as you grab your shot. Those streaks in an image will let your viewer know that these things are moving fast, and with that, a new layer of drama is added to your image. Motion blur is so popular that it is commonly added artificially in photoshop, but the best way to make it happen is not in the post processing, but right in your camera, when you make your image.

If you have your shutter open for a short time, your camera will "freeze" an object's movement. Your subject will appear to be motionless and without blur, and your image will be more crisp. How much time is a "long time" or "short time" for your shutter to be open? Well that depends on your subject, and how fast they are moving.

1/60th is just fine for photographing a person who is posing for a photo, but if you are photographing a hummingbird in flight, the wings of that bird will have so much motion blur as to almost disappear completely at that same 1/60th of a second. A hummingbird's wings can

move as fast as 80 beats per second. That means they can move back back and forth as much as 1.33 times in the time that it takes for your camera to snap that photo at a shutter speed of 60. To *"pause"* the wings of our bird and photograph them

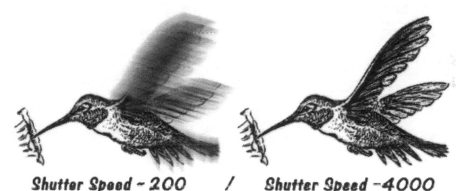

**Shutter Speed ~ 200    /    Shutter Speed ~4000**

*Original image courtesy of the U.S. Library of Congress public domain clipart gallery, edited for this book by Jason Youn.*

as a crisp object, you will have to have a faster shutter speed like 1/4000th of a second or so. That could also be expressed as 6 stops less light, 6 stops of a faster shutter speed, or you could also say the shutter was open for 1/64th of the total amount of time. In that amount of time the hummingbird's wings would only be able to traverse just 0.02 beats, or 2% of one flap of it's wing. That is enough that any blur that the camera captures is not really noticeable. To get one

more stop out of your camera you would have to shoot at 1/8000th of a second. In that time the hummingbird could only complete 1% of a flap.

Likewise, if you are taking a photo of a waterfall at a slow shutter speed, the water will have a nice blur to it. This will give your photograph the feeling of motion. If you use a fast shutter speed, you will completely stop the motion of the falls, and you will capture an image that is crisp and appears to be motionless. How much time is fast and slow in this case? It depends on the speed of the water, and how much blur you want to achieve. Play around with different speeds and see what happens, but to avoid camera shake, use a strong stable tripod.

**Camera Shake**

Hand holding a camera while you take a picture only works if your shutter is fast enough to keep the image from developing a type of blur called camera shake. If the shutter is open for too long and your camera is not on a tripod, your image will blur. "Think of trying to hand hold a set of high powered binoculars."

Unlike motion blur, camera shake is introduced from your camera and lens moving around while the shutter is open. A good fast shutter speed will correct for this problem. If you can't get your shutter fast enough, either because there is not enough light, or simply if you want a slow shutter speed to create a nice motion blur, you will need a tripod or at least a monopod to avoid camera shake. Luckily, you don't have to guess if your shutter will be good enough to hand hold your camera, there is a rule of thumb for quickly calculating this.

This quick rule is just a way to approximate the minimum shutter speed needed for handholding your camera at a given lens focal length. If you notice that you have shaky hands and thus you have problems holding your camera still, you may want to have a faster shutter speed than the rule indicates. On the other hand, if you have hands like a neurosurgeon you will probably get away with a slightly slower shutter speed. Either way, the *1 divided by the focal length* rule is a handy thing to keep in your mind as you work.

Here is how the rule works. If you are shooting with a 50mm lens on a full frame sensor, the rule states that you place a 1 over the focal length, or 1/50, so you would shoot with a shutter speed of a 50th of a second or faster on a full frame camera. Or if your lens is 300mm your shutter speed should be 1/300th or faster. But most digital cameras are not full frame, most DSLR cameras introduce a crop factor of 1.5x or 1.6x. For those cameras, take that calculated shutter speed of 50 and multiply it by 1.6, so to hand hold a 50mm lens on a crop frame sensor,

the shutter speed that you need is 80 or faster. For easy math you will be safe with simply doubling the 1/focal length rule. So lets say you have a 200mm lens, you would set your shutter speed to 1/200th or faster on full frame, or 1/320th or 1/400th or faster on a crop sized sensor. Got all that math so far? Good.

**Image Stabilization**

To help overcome camera shake, and to complicate the math a bit more, many modern DSLR lenses, especially the telephoto ones, have image stabilization, or IS built right in. The efficacy of the IS is normally listed in stops. It's common now for IS lenses to have a 3 stop level of effective compensation. So if you are comfortable hand holding a lens at a shutter speed of 400 without introducing camera shake, and your IS can help you with 3 stops. Turn on that IS and you should now be able to hand hold that same lens with that same camera 3 stops faster. From 400 to 200 is one stop 200 to 100 one more, and 100 to 50 makes 3 stops. Thanks to IS you can shoot hand held with a lens that would otherwise have needed a 400th of second at just 1/50th of a second.

Not all IS systems are as good as 3 stops, look to your owner's manual or check the specs of your lens online to find out how your lens performs. Usually the more the lens costs, the better it will do.

Image stabilization is just one of many tools that help you to keep your shutter open longer; with a good tripod, you can keep that shutter open for as long as you want. If your subjects are moving too quickly, they may be blurry, but the camera shake will be eliminated. If you use a tripod, be sure to turn your image stabilization off. While IS works great for hand holding, it can become confused if there is no movement, like on a tripod, and may actually introduce its own camera shake into the image. If you use a monopod, image stabilization is usually ok. Tripods and monopods will be covered more fully in chapter 5. For now let's get back to more ways to control exposure.

# ISO - The camera's sensitivity to light

So far we have covered controlling exposure by adding or removing a little light from your environment, modifying the size of the hole that light must pass through, and adjusting how long the shutter is open. In other words, we have learned that light comes from your subject (amount of light), passes through a hole in the lens (aperture), for a given length of time (shutter speed), and finally hits the image sensor. The ISO setting on your camera controls how sensitive your image sensor is to light, or how much exposure your image sensor needs to make a photograph.

Our eyes have some automatic light sensitivity built right in, and in some ways it is much like a camera's ISO setting. On a bright sunny day, when you move from the outside of your house to the inside, the new environment can feel dark, and it can take our eyes some time to adjust to this lack of light. For our eyes to go from bright sunlight to nearly complete darkness it can take as much as 30 minutes to fully become accustomed to new light levels. Once our eyes adjust, the room no longer feels quite as dark. Our eyes' sensitivity to light has changed. Eyes perform this action chemically by making changes to intercellular calcium ions and such. Your camera makes changes to its sensitivity to light by changing the gain, or a relationship of output voltage, charge, and capacitance on the image sensor. Simply put, our eyes rely on chemicals to adjust their sensitivity to light and this process can take some time to achieve. Cameras change their sensitivity to light with electricity and this is, for all intents and purposes, instantaneous.

I have known some photographers who don't bother adjusting their ISO. They just leave this setting on auto, either because they don't know what it does, or they're afraid to mess things up. While using the wrong ISO can make your images look grainy, selecting the proper ISO will make choosing the f-stop and shutter speed much easier.

ISO is just an acronym that stands for International Standards Organization. This company sets standards for just about everything. In relation to photography, this number indicates your camera's sensitivity to light, and this sensitivity is adjustable. You may remember buying camera film with different *speeds*. The speed of the film you used to buy is noted by the ISO number.

The ISO setting on your digital camera is exactly like the numbers on the side of an old film canister. One of the best parts of abandoning film and shooting with a digital-SLR camera is that you can quickly change your ISO. In a world of film, changing ISO meant you had to remove the film from your camera and replace it with different film. Or you could carry several camera

bodies, one with each film you want to use. With digital, you can move from one ISO to another and back again with ease.

Much like shutter speed, ISO is expressed with a number. A low ISO number like 100 is less light sensitive and requires more light to make an image, while a high number like 3200 is very sensitive to light and will require 5 stops less light versus ISO 100 to create a well exposed image.

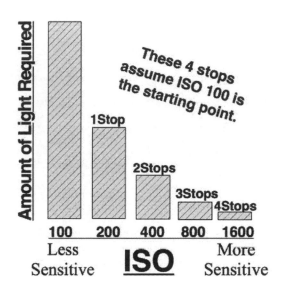

As with aperture and shutter speed, ISO works in stops of halves and doubles. The normal *stops* are 100, 200, 400, 800, 1600, and so on. Just as with aperture & shutter speed, your camera's ISO settings may have the option for ½ & ⅓ stops available. 100 to 200 is one full stop; 100 to 125 is ⅓ of a stop; 100 to 150 is ½ of a stop, and so on.

As with everything in photography, ISO comes with a trade off. As your camera becomes more light sensitive, or as your ISO number increases, your camera will gain the ability to make a useable image in some relatively dark environments. If you like to shoot rock bands or wedding receptions, this is a major plus. Keep in mind, as your camera becomes more light sensitive, your image will have more digital noise or grain and more color noise. Film actually has the same trade off. If you have ever watched an old movie, you may have noticed that there is something almost like a layer of snow over the image, like a million translucent ants crawling on the screen. Digital noise is a little different but the end result looks much the same. High ISO = more sensitivity and more noise, Low ISO = less noise and less light sensitivity.

You don't need to be afraid to shoot at high ISO settings. Usually, sacrificing a little image quality to get the shot you want is worth it. I routinely print images taken at 3200+ ISO. As technology gets better, that ability to shoot a fine quality image at a high ISO will continue to get better. Some of the high end cameras that are out now can shoot at ISO 128,000 and while the image is fairly bad at that setting, they do actually look good enough to hang on your wall at 24,000.

One of the big mistakes that is very easy to make with ISO is forgetting to check this setting when the lighting changes. When you go from a bright place where your ISO is 100 to a dark place where a higher ISO is needed, it's easy to notice the need for a change. The click of the shutter will sound slow, your shutter speed will not be sufficient to keep hand holding your camera and with that slow sounding shutter and the blurry image in the preview screen, you get a nice reminder to change your ISO. But when you go from a dark room where you needed that 3200 to outside in the sun where you only need ISO 100 you don't get this reminder. Your shutter speed will be way up at 8000 and at those speeds your camera can sounds a lot like it's shooting at 1/200th. You won't notice the problem until you start editing your photos and you find lots and lots of grain. Just make it part of your mental check list: "What is my ISO?" Don't start shooting without checking. Alternatively you can just leave your camera on Auto ISO. The advantage is that you won't have to remember to change your ISO around, the disadvantage is that you will give up some control of your image to the camera. There are times when auto ISO is really great but for the most part, I like to decide what my ISO will be.

ISO is a great way to gain a bit more control over your exposure. Keep in mind, every exposure setting sits in relation to every other exposure setting. Adjust one, and something else must also change. This balance of exposure control is called reciprocity.

## Reciprocity

Once you have your proper exposure down, you may want to change the settings on your camera; perhaps you want a faster or slower shutter speed, or you want to use the aperture to affect your depth of field. For every combination of camera settings that yields a proper exposure, there are reciprocal settings that also yield the same proper exposure.

Reciprocity is the relationship between shutter speed, aperture, and ISO. The idea behind reciprocity is simple. Your camera needs just the right amount of light to create a photograph. If your exposure is correct and you change a setting allowing more light into your camera, you must change another setting to remove some light as well. This way, proper exposure is maintained throughout the changes in camera settings.

You have the ability to change exposure in four ways: *light* - add or remove light from your actual setting; *aperture* - change the f-stop to make the hole in your lens bigger or smaller; *shutter speed* - increase or decrease the amount of time the shutter stays open; *ISO* - change your

camera's sensitivity to light. Change one, and your exposure will change; change another in an equal and opposite way and you will correct for the first change in exposure.

Here's a quick example. If proper exposure is f/8 at 1/250th at ISO 200, and you decide you want your aperture to be at f/4, your camera will take in two stops more light. With these new settings, your image is now 2 stops overexposed. To bring the image back to proper exposure, you must either adjust the shutter speed, or the ISO, or the lighting, or all three. To keep things easy for this example, we will change just the shutter speed. If you adjust the shutter speed your camera will need to gather two stops less light, or you need to make it two stops faster; therefore, from 250, one stop is 500, and one more is 1000. So according to the rules of reciprocity the new correct shutter speed is 1/1000th of a second. If, on the other hand, you adjust the ISO, you will need to make your camera two stops less light sensitive, your camera was at 200, so your new ISO should be 50. The following chart shows ISO, shutter, and aperture in relation to each other.

This diagram is set up so that if you want to change an exposure setting, you can find a reciprocal setting with ease. Here's how it works. If you move any one setting to the right or to the left, you must move another setting in the opposite direction. The first example from the above text is shown on this chart. Here f/8 is changed to f/4. This is a move of two stops. To compensate, the shutter speed is moved two stops in the opposite direction, from 250 to 1000. We could have just as easily adjusted the ISO or a combination of the two. Keep reciprocity in your mind as you shoot. It will make it quite easy to adjust any setting to get a desired effect.

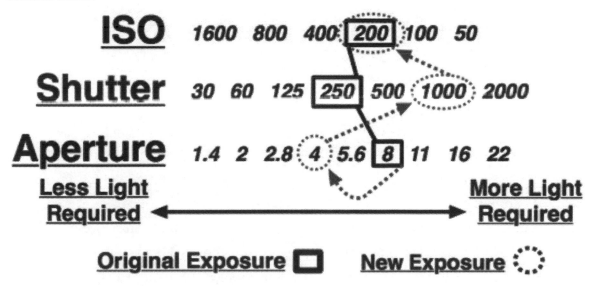

# Color Temperature / White Balance

Color temperature. Even the name can sound a bit confusing. How can a color have temperature or heat? In this case, temperature is not directly referring to thermal energy. Color temperature is just a scientifically accurate way of describing how warm or cool light appears to be.

If you have ever looked at a photo and thought, wow that looks too orange or too blue, congratulations, you are well on your way to getting a handle on proper color balance or white balance.

Photographs can look too orange or too blue because the lights that we encounter in our day-to-day lives have a hue or color cast to them. There is pure white light, but we almost never encounter it. Every light bulb has a color; the sun has a color; a candle flame has a color. We measure that color in Degrees Kelvin, noted simply as the capitol letter K.

If color temperature is not a reference to the actual thermal energy of light, what is it? In the late 1800s, William Thompson or Lord Kelvin applied heat to a block of pure carbon. Somewhere around 1273 Centigrade or 1000 degrees Kelvin (a scale of thermal energy like Fahrenheit or Centigrade), the block began to emit light and glow a dull reddish orange. As more heat was applied the carbon block grew brighter and the color shifted to bright orange, then yellow, then white, then finally around 10,000 degrees Kelvin, blue.

For color temperature, when we say Kelvin, we are actually talking about the color produced by pure carbon at that given thermal temperature. We note that perceived color as K.

A normal incandescent lightbulb is relatively orange and produces light that can be described as being about 2800 K. The light from your camera's flash is normally exactly 6000 K. It just so happens that normal sunlight is around 5500 K but that can change depending on the time of year, part of the world, altitude, time of day, cloud cover, pollution levels, and my daughter's mood -- ok, just kidding on that last part. Everywhere you go to make a photograph, you will have to work with lights that have a slightly different color cast to them. In order to correct for this difference in color, your camera has a tool that can balance the light, or correct for the variances in the K of light. This is the *white balance* setting.

When your camera's white balance is set to a given color temperature, for instance the flash setting (6000 K), you are telling your camera to act as if the color of light from a flash (6000 K) is pure white. Any light that is lower than 6000 K will look orange; any light that is above 6000 K will look blue. The intensity of that color will increase as its distance from that 6000 K white

point increases. If you set your camera's white balance to the incandescent light bulb setting, you are telling your camera to adjust so that 2800 K light is processed as, and appears to be white. Anything below that is orange and above that is blue.

Beyond just the color temperature settings for white balance, there is also color hue. The hue of light has to do with how green or magenta the light is. The white balance settings on your camera will also adjust for this but hue is usually less noticeable and less of a drastic change than color temperature. Even though it is perhaps less noticeable than temperature it still worth getting a handle on.

One of the white balance settings that will effect hue greatly is the setting for florescent lighting. These lights, especially the old non-color balanced versions, have a very green color cast, or hue to them. To compensate, the florescent setting on your camera will shift the hue setting in the opposite direction to introduce magenta and offset the green light.

By changing both the color temperature and the color hue your camera can achieve perfect white balance. Our eyes and brain have white balance built right in. Without even thinking, we automatically adjust the information that our eyes collect, and we color balance the world around us to make white look white. Try this: If you look at a white slip of paper in your living room at night by candle light, you will actually be seeing a paper that is reflecting deep orange light; in a sense, you are looking at an orange piece of paper. Because our brain tells us that the paper is white, we still see it as white. Cameras can do an even better job correcting for color casts than we can, but you have to tell your camera what to do and how to do it. Luckily there are four easy ways of setting the white balance in your camera: auto, preset, exact K, and custom.

First, you can simply leave your camera on the **auto white balance** mode. Sometimes this is the best way to go. It's easy and the camera generally does a fairly good job. The downside, however, is that each and every photograph has its own unique white balance setting. This can make editing much more difficult. If you have 500 photographs and each one has the same white balance issues, you can batch edit them, or apply a change to many photos at once, and fix all of them very quickly. If, on the other hand, each photo is just a little different, then you will have to fix each one individually. Another down side is that auto white balance is more of an approximation to proper white balance. It will get you close but it will rarely be exact. For all its downsides however, auto white balance is fast and convenient. If you want to just pick up your camera and shoot, it can get you up and going in no time. But unless you're just taking vacation photos or party snapshots, you should avoid this as much as you can.

The next thing you can do is select one of the camera's built-in, or **preset**, white balance settings. Most cameras have a setting for sun, shade, overcast, tungsten lightbulb, fluorescent lightbulb, and flash. Some also have a setting for underwater, and your camera may even have more settings.

The nice thing about these settings is that they are easy to use and, more importantly, they're consistent from one shot to the next. Unlike auto mode, each image will have the same white balance settings. This makes editing your photos a whole heck of a lot easier. It is normally not perfectly accurate, but it's really close. If you don't have time for custom balancing, this is the way to go.

Next you can select the exact temperature **K**. On my camera I access this by selecting K on the white balance menu and then I have to tell the camera what K is in another menu. It takes more time to set up but it does give a lot of creative control over the color temperature. If you are too warm, you just drop down a few K; if you are too cool, you just come up a few K. This is a very accurate way to work. The downside is that it does not correct for hue; that has to be done someplace else. On the other hand, hue is not something you normally have to mess with, so that is not a big deal. This setting can take some real getting used to, but depending on your shooting style, it can be worth the extra time. I know a few photographers who use this almost exclusively. Even if you decided not to shoot in the K white balance setting, at least play with it. It will give you a good understanding of how color temperature works. Using an auto mode or preset mode will serve you best if you understand why the camera is making its decisions. To do this you need to understand how to shoot in fully manual mode.

The last way to adjust for color, and the most accurate way, is a **custom white balance**. This is done by taking a properly exposed test shot of an object that reflects red, green, and blue light equally. This can be a white card or 18% grey card or several other things. You then tell your camera to use that image to set the custom white balance. However, be careful when selecting your white or grey card; most things that we think of as pure white are really not white at all. Even printer paper has just a bit of cyan mixed in to make it appear brighter. I have a photographic target that has three panels on it, pure black, 18% grey, and pure white. I use this to set my custom white balance on my camera. It is fast, accurate, and also helps my white balance and exposure to be spot on. Targets like this sell for about $40. Most cameras access Custom W/B in different ways. On my camera the process is simple: I take a photo of my W/B target, set that as the custom white balance, then set the white balance on my camera to custom. Your camera may be different, you can find directions on how to set a custom white balance setting in

your camera's owner's manual. I love to use this custom W/B setting. Editing photos is much, much easier when the original image is done right. You don't have to use custom to get great photos, the other settings are just fine, and each has some pros and cons, but at least play with each; learn each one so that you can decide what method you like the best. For me there really is no single best option; each situation demands a different method, and I use all of them.

Once you have captured your photo on your camera, you can usually work on the white balance more when you edit the images on your computer. We call this fixing it in post production, and a common expression is to say that I'll "fix it in post." It is, however, important to get at least a reasonably good white balancing done in the camera. It is better to get close to perfect. If this sounds hard, don't worry; this will be easy with just a little practice.

Here is a neat trick to help you get good at noticing white balance in your every day life. Next time you are at a large hardware store, stop by the lighting department. You will probably see a setup with several different kinds of light bulbs shining on a swatch of fabric or colored card. These are set up to show off the different color temperatures available. Some will be CFL, some LED, and some will be incandescent. For my money, the best light for home use comes from quartz halogen bulbs. The color is nice and warm, and the light is flicker free. (I also really like incandescent bulbs, but those old style incandescent bulbs that we all grew up with are now, as of 2012, illegal in the USA. The US Department of Energy has ruled that they use too much electricity and are no longer permitted to be manufactured. You can, however, still use, buy, and sell them but they cannot be built or created. Thankfully, Phillips came up with a way to make a bulb very similar to the old style 30% more efficient by reflecting some of the heat back toward the filament and you can still buy that one, for now... I bring this up because we live in a highly regulated and rapidly changing world. The lighting that we make and use for photography today may soon be replaced by new technology or via legislation.) Unless you are only working in a photo studio, you have to stay ready to adapt to changing lighting conditions. As you get good at noticing different lighting you will also notice your friends' and neighbors' lights, even the lights at the park. For example the lamps in the light poles in my neighborhood recently changed from mercury vapor to LED. Everywhere you go there will be different lighting. You just have to train your eyes to notice, get ready to have your shooting adapt, and the color quality in your photography will improve.

*Chapter 4*

# Lenses

Ok, we have exposure control covered with the four settings: light levels, time (shutter), aperture, and ISO. Getting the light into the camera and focusing that light is the job of your lens, which focuses and narrows the light from your scene onto your image sensor. Our eyes also have a lens, and with that our eyes and brain have the ability to focus on just one detailed object in the center of our vision or take in an entire world and see what is going on across a panorama of vision. We can have a sense of what is all around us even when it's not exactly in focus. Camera lenses are not as versatile, however. They only see what is right in front of them, they only focus on one thing at a time. Your camera has little to no sense of what is going on outside of its own field of view. On the other hand your camera can do things our eyes can't. With interchangeable lenses your camera can zoom in on a grain of rice, or an eagle thousands of feet away; it can take in 180 degrees of a landscape or isolate a single subject in a crowded place. For every need there is a lens and knowing how they work and how to select the right lens for the job will help you along your way.

Your lens is the cylinder containing the round glass on the front of your camera that allows light to pass through on its way to the image sensor; it focuses and controls the light that your camera takes in, and if you have an SLR, or mirror-less compact camera, it is interchangeable. Every lens has an attribute or property to how it modifies the light as it focuses it down to make an image. Some lenses zoom, some don't; some will act like a telescope, and some will capture the entire room, while some will focus down like a microscope on a tiny object. Some will distort the world a lot and some very little, but all have just one job, to collect and focus light on the image sensor.

Every camera has a lens that will more closely match the world as the human eye sees it. It won't enlarge the world, make it smaller, or distort it. It won't be zoomed in or out; it will just cause the photo to look much as the world looks in real life with our human eyes. This type of lens is called a *normal* lens, and it's worth owning a lens (either a prime or a zoom) that covers this focal length. A normal lens focal length is not the same for all cameras. To find the actual

normal lens focal length for a given camera there is math involved. Don't worry; this math is not something you need to know but it's nice to have this info anyway, and here it comes.

Cameras have a square or rectangular image sensor. You may remember from geometry class that a rectangle is just two triangles put together, or to put it another way you can connect two opposite corners of a rectangle and make two triangles. That dividing line that you just created is actually the hypotenuse or longest lines of the newly formed triangles. For all cameras the hypotenuse of the image sensor, or piece of film, is what gives us the size of its normal lens. A full frame 35mm camera has a sensor size of 36x24mm. The hypotenuse of that rectangle is about 43mm long, so a 43mm lens would be perfect. The next closest thing commonly on the market is a 50mm prime and it's close enough, so a 50mm lens is considered to be the normal lens for a 35mm film or full frame digital camera. If you shoot a DSLR with a crop sensor like the APS-C, then the normal lens is about 35mm. If you use a micro four-thirds sensor camera, your normal lens is only about 25mm. In other words, an image from a 35mm camera with a 50 mm lens is about the same as an image from an APS-C camera with a 35mm lens, and that is about the same as an image from a four-thirds camera with a 25mm lens.

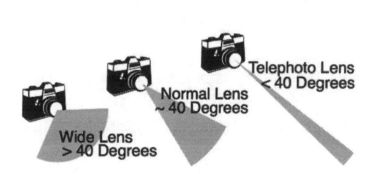

In every case the field of view is about 40 degrees horizontally or left to right. If a lens is shorter than normal length like a 16mm, it will take in more than about 40 degrees, this is a wide angle lens. If it takes in less than about 40 degrees, like a 200mm lens for example, it is a telephoto.

Because the focal length of a lens is what determines its field of view, photographers refer to wide angle lenses as *short lenses* and telephoto lenses as *long lenses*.

Normal lenses, wide angle lenses, and telephoto lenses all have different characteristics and will produce different images. It is a good idea to have at least one lens from each category in your camera bag.

# Three Lens Types & Their Attributes

### Normal Lenses

- Normal lenses will show the world in a manner that is similar to how our eyes see it.
- About 40 degrees horizontally of your surroundings will fit into your frame.
- Depth and perspective will look normal.
- Features and proportions of your subject appear much as they do in real life.

### Wide Angle Lenses

- A larger area than normal, or greater than about 40 degrees fits into your camera frame. This is handy when you cannot move your camera back any farther, like for an indoor group shot.
- Similar to objects in the rearview mirror of your car, objects in your camera will look smaller in your frame from the same distance away when compared to a normal lens.
- It exaggerates depth or distance as it recedes from the camera. For instance an object will look further away from its background than it really is.
- Your depth of field will generally look to be larger at a given f-stop.
- Camera shake is less noticeable; thus, you can hand-hold your camera at a slower shutter speed. Remember the 1/focal length rule? Wide lenses have a shorter focal length.
- Features of your subject become more spread out and distorted, especially near the edge of the frame. A portrait may have a large nose and smaller ears for example.
- Extreme wide angle lenses cause straight lines to appear to bend and distort as they cross through the frame. This kind of distortion can make buildings appear to bend.
- Because of their wide field of view these are often used for landscape and architecture, but have many other uses.
- On the extreme side of this category is the fisheye lens. This lens severely distorts the world and some fisheyes can take in as much as 180 degrees of the environment.

### Telephoto Lenses

- A smaller than normal area fits into your camera's frame. Much like a set of binoculars, or a telescope, this lens is good for subjects that are far away when you do not have the ability to move closer, like at a sports game or in wildlife photography.
- Objects in your camera will look larger in your frame from the same distance away when compared to a normal lens.
- Your depth of field will generally look to be smaller at a given f-stop.
- It compresses depth or distance as it recedes from the camera. For instance, an object will look closer to its background.
- Camera shake is more noticeable; thus you must have a faster shutter speed to hand hold a telephoto lens.
- Features of your subject become flat, i.e. the distance from front to back of your subject appears to lessen.
- Because of the compression of distance and the narrow depth of field, these are often used as portrait lenses.

# Zoom & Prime Lenses

So far we have really only talked about lenses that have a fixed focal length, these are known as prime lenses. Your camera however probably came with a kit lens that has the ability to zoom in and out giving you more versatility without the need to change lenses. Both zoom lenses and prime lenses have pros and cons.

Because prime lenses do not change their internal configuration of lens elements to zoom in or out, they need fewer pieces of glass, and fewer moving parts inside of them. As a result, the image quality of a given lens is generally higher with a prime lens that is built to the same specs as its zoom counterpart. Having less glass also means that a prime lens weighs less and is easier to carry around. I keep a 50mm f/1.4 in my camera bag most of the time. It is light, relatively cheap, packs well, is great in low light, and has a nice small depth of field when the aperture is wide open at 1.4. The down side to a prime lens is that, if you want to change focal lengths, you must change lenses. Zoom lenses solve this problem nicely; a zoom lens can change its focal length with one simple motion.

Most lenses sold today are zoom lenses. Their ability to go from wide to normal to telephoto makes them the perfect choice for most photographers. If you want a wider frame, zoom out; if you want a tighter frame, zoom in. These lenses do weigh more, take up more space, and generally cost more money to get the same quality of image. The ability to quickly select your desired focal length and then quickly change it again usually makes the added weight, cost, and loss of quality worth dealing with. I own many lenses and most of them are zooms.

# Focus

Just like with our eyes, an image captured with a camera can be in focus or out of focus. When something is in focus, it appears sharp, clear, and crisp. When it's out of focus, it appears soft, blurry and fuzzy. We don't normally need to consciously focus our eyes because our brain and eyes actually manipulate the shape of our cornea or lens in our eye automatically. Like our eyes, cameras also have lenses. Our cameras lens, however, is made of glass and cannot change

the shape of its lens to focus. Rather, it must move the focusing lens, or *element* back and forth in relation to the other internal lenses to achieve optimal focus.

If you shoot with an SLR, then before being able to properly focus your camera, your diopter should be properly adjusted. This device is in the reticle or viewfinder of your camera. The diopter allows the viewfinder or reticle to be adjusted for your individual eye. This way you can shoot without your glasses. Notice the small adjustment wheel near the eyecup of your viewfinder? This will move a lens back and forth in your camera's eyepiece so that an in focus image in your camera will look in focus to your eye. To make this adjustment on a DSLR or SLR, select a dust free environment, carefully remove the lens from your camera. Look through your eyepiece and aim your camera at a blank white wall. Now adjust the wheel until the lines and or boxes in your reticle come into optimal focus. Your reticle should looks something like

this. The small boxes are the autofocus points. If you have vertical or horizontal lines, they are there to help you compose your image. Once your diopter is adjusted and the boxes are in focus, carefully replace your cameras lens.  Your camera is now adjusted for your eye.

There are two basic types of focusing: autofocus and manual focus. Most modern cameras do a fine job of autofocusing, and there are several different autofocus modes your camera can employ. If you want to leave your camera on full autofocus, the computer inside your camera will decide for itself where to place its focal points. Some cameras use face recognition technology to place autofocus points on your subject or group of subjects. As cameras get smarter, this will get even better. Often this is a good way to go; it is simple and can work well, but you give up a bit of control with this method.

If you want to use autofocus, but you still want to have control over which part of the image is in focus, you can use selectable autofocus points and autofocus lock. This is what I do most of the time.

### Autofocus Points

Autofocus points "AF" are the dots inside your cameras reticle that the autofocus computer in your camera uses to focus your image. Your camera has many of them, generally more expensive cameras have more. In full auto mode your camera automatically selects the points that it thinks are the best and uses those to focus. You can probably see these points within your camera's eyepiece. They will often light up as the camera calculates and locks on to its focus to confirm and let you know what points your camera is using.

If you want more control, however, you can tell your camera exactly what focus point to use. For this you will have to look to your camera's owner's manual to see how to select this option for your camera. If you select a specific AF point, your camera will always use that point to select its autofocus. But what do you do if the point you have selected is not the point of the photograph that you want to have in focus? This is where *Autofocus / Exposure Lock* comes in handy. I like to just use the center focal point only and use the AF/AE lock feature and then recompose my framing.

### Autofocus Lock

Autofocus lock, or AE/AF lock tells your camera to focus, select its exposure, and then hold those settings. Once it is engaged, your camera will not refocus and will not adjust is exposure settings. AF lock is used by pressing your shutter release button halfway down. (You may have to turn on your AE/AF lock feature in your cameras settings). Look through the view finder, find the spot that you want to have in focus and frame your camera so that your selected autofocus point is over that spot. Press the shutter release button halfway down and hold it there. Wait for AE/AF confirmation from your camera in the form of a blinking box in the reticle or a beep noise, then re-frame your image so that the composition is the way that you want it to be. Notice your camera will not re-focus. Now press the shutter release button the rest of the way down. Your camera will take a photograph. A nice feature of this is that there will be no hesitation or lag when you press the button the rest of the way down because the image is already focused. So if you know you have a shot that must be timed perfectly you can get your focus early, compose your shot, and wait for the moment to happen.

While I love autofocus and use it most of the time, sometimes it just does not work. There are a few things that can mess up the autofocus computer in your camera. Probably the most common time where AF will fail is in low light situations. Your camera makes its focus decision

from the data it gets from the outside world; that data is compiled from the light your camera collects so if there is not a lot of light, there will not be a lot of information for your camera to use in its decision-making process and it will not be able to attain focus. There are some things you can do to help this situation. The first and simplest thing you can do is to just buy more expensive gear. I know most people don't want to hear that but a top of the line camera lens will focus better in low light than a cheap one. More money is not the only solution and if you're already on a shoot, well then that won't be an option.

Another thing you can do to correct for low light levels is to make sure your AF point is aimed at a lighter portion of the scene. For example, your are shooting a portrait of a groom and you are using the groom's tuxedo lapel to get your focus. Your camera may seek back and forth to try and get a grip on where that focus should be. Sometimes it will take a while; sometimes it won't work at all. If you get your focus from the bright red vest or tie, on the other hand, the focus will happen faster. This will affect the exposure of your image a little but you can fix exposure in post; you can't really fix depth of field. Now having given the tux focus example, I like to get my focus from the groom's eyes, but the jacket vest example does a good job of illustrating how you can help your camera's AF when it is struggling.

Your camera may also have an AF Assist Beam option. If it has this, make sure that setting is turned on. The AF assist beam puts out a bit of infrared or sometimes visible light that your camera uses to help it gain accurate focus. This temporarily adds light to the environment for the camera to use for focusing; it is gone before the image is made so it has no effect on the recorded image. Many times cameras come from the factory with this turned off to save battery power. If you are using an off-camera flash to add light to your scene, these off-camera flashes have a more powerful IR AF Assist Beam built into the flash so the camera's focus computer will work even better.

Autofocus is a great fast way to make sure your images are crisp and clear, but sometimes it fails, or other times you may not want to use it; for those times your camera has manual focus.

**Manual Focus**
Before autofocus was invented, the only way to operate your lens was with manual focus. There were times when measuring tape and marking distance was just part of the photography process. There were sports photographers that would pride themselves on being able to focus on any athlete and get that shot. Thankfully those days have gone the way of the travel agent.

Technology has almost completely made all of that obsolete. But no tech is perfect, there are times when autofocus just won't work, and so, being able to focus your camera on your own, without the AF assistance, is an important tool to have at your disposal. Not only does it give you complete control over your focus, sometimes it's your only option. Your camera may have a hard or even impossible time focusing in low light. When this happens, manual focus may be your best option.

First place your camera in manual focus mode. Consult your camera's owner's manual on how this is done. On my camera there is a switch on the lens and that's all; many other cameras and lenses are different.

Once in manual focus mode, if your lens has a manual focus scale on it, you can just set the lens to the correct distance and you are all set. If you can't focus that way, simply look through your camera's eyepiece and twist the focus ring on the lens back and forth until the image looks its sharpest. Once your image is focused, take your photograph. If you have done all this correctly, your image will be in focus. If you are in a tough situation and focus is hard to achieve, try using a larger depth of field. (Higher f-stop or constricted aperture) If your depth of field is large enough, your focus can be way off and your image will still look to be in focus.

You can also use something known as *hyperfocal distance*. To get an idea of how to use this you must first know what depth of field is, so we will come back to that after this next portion.

### Depth of Field

The subject that your camera focuses on may not be the only thing in focus. Depth of field (DOF) is the entire space in front of your camera where the image appears to be in focus. It is not just what you focus on. For example you may focus on something that is 15 feet away, but your depth of field may very well be from 10 feet to 25 feet. So if your subject is between 10 feet and 25 feet from your camera, it will be in focus. Anything closer than 10 feet or further than 25 feet will be out of focus. FYI, focal distance is measured from the location of the image sensor or focal plane, not the lens. There is a small marker on the top of your camera somewhere that looks like a circle with a line through it. That line is your camera's focal plane; if you want to measure out your focal distance with a ruler or measuring tape you will measure from that point on your camera.

As with most things in photography, there are many ways to control your depth of field. You can control it with the *focal length* of your lens, the size of your *aperture*, and your subject's *distance from the camera.*

Assuming the camera and subject do not change location, or distance from each other, the DOF decreases as the focal length of the lens increases. So a longer lens, like a telephoto, creates a smaller depth of field, and a shorter lens, like a normal or wide angle lens, creates a larger depth of field, so a wide angle lens has a larger DOF than a telephoto lens at a given aperture and focal distance. While it is good to keep focal length in mind when shooting; the simplest and most common way to control your depth of field, however, is with your aperture.

You already know that your aperture is used to control exposure, but there is another function. Depth of field increases as the size of the aperture decreases. That is to say your depth of field is much larger at f/22 than it is at f/2.8. Aperture is the primary and most popular way to control your depth of field. A blurred background really is a great way to isolate your subject. It makes for a beautiful image, and it's not hard to do. You may have heard the word or seen examples of Bokeh, pronounced BO-KEH (from the Japanese word "boke" (暈け/ボケ) meaning fuzzy). This means the background is out of focus and there are points of light or highlights in the background that show up as soft fuzzy points of light in the shape of your aperture. Shallow depths of field, bokeh, and nice blurry backgrounds all come from a wide open aperture.

If you want to make a portrait, or any photo where the background is blurred out, shoot with a wide open aperture (f/2.8, or f/4 for example). Focus on the eyes. If you are shooting a portrait with a 200mm lens at f/2.8 and you focus on the eyes of your subject, the depth of field will be so small that the tip of the nose, shoulders, and even the hair near the back of the head of your subject will be just slightly out of focus. This can create a strikingly beautiful image with impact. But focusing quickly can be hard; you will probably want your subject to hold still and take time to compose your image. Make sure your shutter speed is fast enough to handle a long lens.

If you are shooting action sports or wildlife photography and your subject is moving around rapidly, perfect focus may be difficult. If you have a larger DOF, your inaccuracies with your camera may be hidden by the fact that so much more of your photo is in focus. Shooting at a smaller aperture like f/11 or f/16 will give you that larger depth of field. Most landscape photographers shoot their work on a tripod with a very stopped down aperture, such as f/16 or

higher. This keeps the foreground, background, and everything in between in perfect focus. You can force your camera to use the aperture you want by either shooting in full manual mode or by selecting aperture priority.

The last thing that affects depth of field is the distance from the subject to the camera. All other things being equal, a close subject will yield a smaller depth of field and a distant subject will create a larger depth of field.

Controlling your depth of field will help you add a bit of drama and impact to your image. The exact same scene can look vastly different with a different DOF so keeping on top of this is important. Remember though everything has a give and take. Adjusting your aperture to change your depth of field also changes your exposure. If you stop down to gain a larger DOF, you will let in less light, so to compensate you will use reciprocity (information for reciprocity is located near the end of chapter 3). So you were shooting at f/4 @ 1/500 and want to shoot at f/11, a three stop difference, you will have to adjust three stops some place else; one option is your shutter. 500 down three stops is 60, your new settings are f/11 @ 1/60. As I've said before, there is always a give and take.

Apart from being able to adjust the aperture to control the size of your depth of field, it is important to know the *2/3rds Rule.* The depth of field is always situated in a way where 1/3rd of what is in focus is in front of your focal point and 2/3rd are behind the focal point. For example, if your depth of field is 15 feet long, then 5 feet in front of your focal point will be in focus, and 10 feet behind your focal point will be in focus. For a quick example see this image.

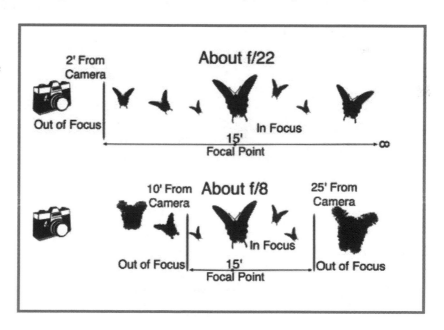

### Hyperfocal distance

Depth of field has a starting point measured in distance from your camera's focal plane and an end point. That end point can be a distance from your camera's focal plane like in the above example for f/8 or it can be infinite like the above example of f/22. When your focus goes from a given distance to ∞ you have a nice advantage. Let's say your focus is 3' to ∞, you know that you can point your camera in any direction, without looking through the lens and everything that is farther than 3' will be in focus. This is great news if you want to shoot from the hip, or take photos discretely without holding the camera to your face.

Every lens has hyperfocal distances for each f-stop. This is useful information. Let's say you have a 50mm lens at f/16 and your subject is 40 feet away. You can focus your lens for 40 feet. Your subject will be in focus, and your depth of field will go from perhaps 20' to ∞. But you can get a greater DOF than that if you would like. For example, let's just say that the hyperfocal distance for 50mm f/16 is 17 feet. Set your camera to 17 feet and everything from perhaps about 3' to ∞ will be in focus. Using hyperfocal distance, the depth of field just got bigger. The reason this works is that once the focus hits ∞, moving that focus farther away can only affect the near focus line, not the far, because you cannot add to infinity. If you move the focal point closer than the hyperfocal distance, then you are no longer focusing to ∞. If you move it farther than the hyperfocal distance, then you are still focusing to ∞, but your depth of field is not as large as it could be.

Autofocus these days is so good that you will probably never need to use hyperfocal rules, but it's good to know about them. There was a time in the days of only manual focus that many sports photographers simply set their lens to hyperfocal and didn't worry about focus. Those cheap plastic disposable cameras that focus 3' to infinity use hyperfocal rules, and of course spies and private investigators use it so that they can walk down the street with the camera at their side and take photos; to most observers it just looks like they are holding a camera but in reality the hyperfocal distances let them make clean crisp photographic evidence logs.

If you want to play with this type of shooting, make sure you have a lens with a focus distance scale so you know what your focus settings are, and get yourself a hyperfocal distance chart. You can get them cheap at your local camera shop, or you can even print them off for free online.

# Composition & Other Rules of Art

## Painting With Light

The first time I went on a guided photographic expedition, it was still the good old days of film. Proper camera work was more important because you couldn't guess and check like you can with a digital SLR camera. If you made a mistake or miscalculation, you wouldn't know about it until your prints came back from the lab. Most of us were shooting Fuji Pro-V 35mm film at about $11 per roll plus another $6 to develop it, or about $0.70 per shot, so we didn't want to waste money on miscalculated camera settings.

One of the girls in our group had a strong background in painting and that was about it. She would ask questions like what is an f-stop, or what do you mean wide angle lens? We all thought her photos would turn out poorly done and overexposed or out of focus. The last night of the trip was show and tell night. We all got together and showed off our past work and newly developed images from the trip. Everyone's was good; some were great. For the group I was sub-par, but I was young and didn't have much time behind the lens. Soon it was that poor confused painter's turn. You could tell most of us in the room thought her images would be a waste of time. We were wrong. Her photos were stunning. Her composition, weight and balance, use of color, line, and shape were all without match for the room. The girl who knew almost nothing about cameras (nothing about chapters 2, 3, & 4) took us all to school. All she did was turn her camera dial to landscape mode for landscape and portrait mode for people. For the landscape shots she used a tripod, and she used her carefully honed knowledge of composition and art; the camera did the rest.

I tell you this story not to convince you to forget about chapters 2 through 4; rather, I tell it to encourage you. It's good to know your camera inside and out. It's better if you can calculate reciprocity quickly and on the spot. But don't worry if you forget a thing or two about your

camera. If you keep in mind the simple principles of art, you will do fine. If a picture is worth a thousand words, your camera is a word processor, but composition is the language. A well-composed photograph is like a well-written book. The girl with no clue how to use her camera had a background in painting; she knew how to compose an image. While the rest of us were taking photographs and snapshots, she was painting with light.

## Use a Tripod

I have been asked time and again for advice on what kind of camera gear to buy. Most of the time the answer is a good tripod and an off-camera shutter release button. For this you will need to go to a camera store, not Best Buy. The tripod should be sturdy and well made. Get ready to spend at least $100 on the tripod, minimum. It's easy to spend much more, and if you can afford it, go for it.

Hand holding a camera while you take a picture only works if your shutter is fast enough to keep the image from looking blurry. If the shutter is open for too long and your camera is not on a tripod, your image will blur. Keep in mind the *1/focal length rule* from the chapter on shutter speed.

Most cameras will let you set the shutter speed to stay open for as much as 30 seconds, but with an off-camera shutter release button with either a built-in timer or button lock mode, you can keep that baby open for as long as you like. If you are shooting film there is almost no disadvantage to a very long exposure. With digital images, the chip can build up a charge and introduce noise. This is not such a bad thing but it's good to know that on a very long digital exposure you will get more grain at a given ISO than from a short exposure. Either way, to take a long exposure in excess of 30 seconds, you will need an off-camera shutter release button.

Beyond just the ability to keep that shutter open, there are two more benefits to the off-camera button. One, even on a tripod, your hand can introduce camera shake when you touch the camera to take the picture. Two, sometimes it can be uncomfortable to reach over and press the on-camera button to take a new photo. Your tripod may be high up or at a weird angle. The off-camera button will let you keep your hands where you like and on a cold morning, keeping your hands in your pocket is a real plus.

Beyond your hands introducing camera shake when you use a tripod, your camera can actually introduce camera shake in two ways. One is with the image stabilization function of your camera, the other is the mirror in your camera. We mentioned earlier that IS can introduce camera shake when on a tripod, so turn that off, and if you really need to eliminate camera shake all together, use a feature on your camera called "mirror lockup." (If you have a mirrorless camera you won't need to mess with mirror lockup since there is no mirror in the first place.) When you take a photograph with your DSLR, your camera first moves a mirror up and out of the way of the shutter, then the shutter opens, your camera makes the image, the shutter closes, and the mirror comes back down. This mirror moves very fast and though it is very lightweight, it still introduces some vibrations that take a half second or so to settle down. If the camera were to operate normally those vibrations could show up in your photograph. The "mirror lockup" function allows the mirror to move up when you first press the shutter release button, then after the camera's vibrations settle down, the shutter opens; this eliminates camera shake from the mirror movement. You will want to consult your camera owner's manual to find out exactly how to enable this on your camera.

So a tripod with no IS and sometimes with mirror lockup will help you get that very crisp shot, but another benefit of a tripod is that it forces you to take your time and compose your shot with care. Rather than running and gunning like a seasoned press photographer, tripod users have to think about what they are doing. Good composition is a cornerstone of good photography, or any art for that matter. With good composition you can literally set your camera to full auto mode and if your composition is good enough, your photo will turn out great.

# The Rule of Thirds

Perhaps the most widely talked about and best known artistic principal is the *Rule of Thirds*.

These days this is a common rule that is taught at just about every single artist school, but it was only recently that the **rule of thirds** was given a name. The first known reference comes from Sir Joshua Reynolds in his book *Remarks on Rural Scenery* (1797). Discussing dominant and subordinate areas of light and dark in a painting, he noted that the light and dark areas of the painting should not be the same size. Rather the dark area should be about twice the size of the light, and that the center of interest should be offset to one side. Reynolds named this principle the rule of thirds, and it has since evolved a bit and become a staple of design theory.

The idea is simple; divide a rectangular image vertically into thirds, and horizontally into thirds. The dividing lines are where interesting subjects should be placed within the image. The four points where the lines meet should normally be the focal points of your image. Think of the rule of thirds as a good starting point for composing your image. This is not something that is set in stone but if you start with this composition tool and work from there, you will like your results.

Just for some examples, the next few images show the same scene, The left image does not use the rule of thirds very well. The right image makes better use the rule of thirds. In this first landscape image the tree is in the middle of the frame left to right, and the horizon is basically in the middle top to bottom.

Notice how the composition is improved by moving the tree to the left third line, and placing the horizon on the bottom third line. By using the rule of thirds

the same image is made just a bit more interesting.

Below is an action shot of a guy I made up just for this book. I guess we can call him Bob. Here Bob is reaching to catch a football. The left image is not composed well, Bob is tiny and in the middle; the football is right above him, and the left and right portions of the frame have nothing going on. In the right image, Bob's face is on the right vertical third line and the football

is at the intersection of the left and top line. The framing has less unused, or negative, space. Of the two football images, which photo do you like better?

This last example for the rule of thirds, is a closeup portrait of Bob.

The left image shows Bob's face just placed in the center of the frame. It's alright, at least Bob made it in the photo, but it's not great. In the right image, his eyes are on the top third line and the left and right third line, and his shoulders are on the bottom third line. There is also less unused space above his head. The composition on Bob's right portrait is much better than in his left, and most of that is because of the implementation of the rule of thirds. All that was done to change the framing was to zoom in a tad, or take a step forward, and pan down just a bit.

The composition of an image tells a story, and many times that story can have major improvements with just small camera movements. If your image lacks impact, try reframing it. By using the rule of thirds, we were able to improve each of these images with just minor changes. Keep this in your mind when you shoot, edit and print. Your images, the story they tell, and your audience's reaction will be better if your images follow the rule of thirds. But this is not the only artistic principal to consider, and from time to time you may want to break this rule, or give more importance to another rule. Perhaps just as important as the rule of thirds is balance.

# Balance

Photographs, like any other two dimensional work of art, are subject to *balance*. When a photograph appears to have more mass or stuff on one side of it than the other, it is not balanced. It can be top heavy, left or right heavy, or bottom heavy. This can have the effect of giving the viewer an uneasy feeling. If that is the look you are going for, great! Alfred Hitchcock often times use images that were out of balance to do just that, make people feel uncomfortable and scared. But for the most part you probably do want a balanced well-composed image. To fix an out-of-balance image, you can place another object on the other side of the frame. Like placing a weight on an out-of-balance scale, this will help to balance out your composition.

Because negative space, or empty space, plays a role in composition, the two objects do not have to be the same size or shape; rather, it is normally better if they are not the same size, although they can be if you like. Much of this just comes down to personal preference.

In the left image below, Bob is just standing in a field. He uses the rule of thirds well, his body is on the left third, his head on the top third line, it is obvious that he is both the center of interest and the subject of the photograph. But there is a lot of unused or negative space on the right side of the frame. The image is heavy on the left. To correct for this in the right image, we happened to have a cheap plastic man-horse thing handy so the production assistant carefully

placed that in the frame and instructed Bob not to move, and poof, the photograph is now balanced. The horse is also creating leading looks but we will get more info on that in a moment.

## Fill the Frame

Most of the time, your composition will improve if you fill the frame with your subject. There are, of course, times when this is not true, but most of the time it is. You can make your subject larger in your frame by simply getting closer or by zooming in. Each action will have a slightly different effect, but both will make your subject larger in your image. You can also crop your image later on your computer but the more you crop, the more quality you will lose. Try to get your image composed well in your camera. It will make editing your photographs just a little easier.

## Color & Brightness

Composition is a major factor in letting your viewer know where to look within your photograph; it lets your viewer know what is important, and what the photo is all about. Good composition will add depth and drama to the story that you are telling, and can make or break a photo, but it is not the only thing that helps tell your viewer's eye where to look.

When working with color or black and white, keep in mind that the brightest or boldest color will attract attention. If you have a bright spot in your photograph, or a bold color in your image, the viewer will focus on it first before noticing the other portions of your photograph. This can be a big help to your composition, or it can detract from it greatly. If it's not an intended part of the composition it will detract from what you want your viewer to see.

If you have a bright spot in your frame, you can try to make that a focal point, use it to balance out another portion of the composition, or cut it out of the scene all together to avoid distracting your audience. If it's in the frame, people will notice it. Bright colors will appear to have more mass or weight in a photograph than a muted version of the same object and will draw your viewer's eye. If you have two equally sized shapes, one bright and the other dim, the brighter portion will overpower the dimmer section of your work. If you can't get rid of the offending object, incorporate it. Perhaps you can balance it with another object, or perhaps it can become the main subject.

In the 1950's, an artist named Mark Rothko created paintings of colored rectangles. This was a time when abstract art was new and trendy, and Rothko's work was simply about shapes, line, and design. Though many of his works were simple, they still managed to appeal to a wide audience in a positive way. One of my favorites is just two rectangles on a simple background. The larger shape is a blue rectangle. Lying just below that is a smaller rectangle painted with blue's complement, yellow. The blue takes up the top two thirds of the frame and the smaller yellow is just the bottom one third. This simple work of art is an excellent example of how color and brightness can be used to balance an image. Just as size and shape can create balance, complementary colors can be used to balance each other out. The brighter warmer color, yellow,

is more dominant, and thus it was given half the area of the cooler blue tone. If the colors were given equal position, the yellow would overpower the blue, the composition would be out of balance, and the work would likely not have become popular. Rothko made the blue twice the size of the yellow, and in doing so, achieved balance, and his painting was a success.

You can make the same kinds of decisions with photography, you just have to keep an eye out for color and brightness. When composing your frame ask yourself if the bright portion of your frame adds to the composition or detracts from it, then get ready to recompose or even rearrange the scene if necessary.

*Mark Rothko - Red, Orange, Tan, and Purple, 1954 - Oil on Canvas 84"x68"*

55

# Frame Within a Frame

Sometimes letting your viewers know where to look is as simple as giving them information that directs the framing of the image down to just one portion of the total frame. Another technique that is popular in both photography and cinema, "frame within a frame" is just about as simple as it sounds.

Imagine an apple pie cooling in a farmhouse window on warm spring day. It was just placed there recently and steam is rising from the golden brown crust. Did you imagine the window frame and curtains around the pie? Did you think of some painted wood paneling that surrounds the window, or perhaps you were inside of the house and you saw a kitchen sink, or perhaps a table below the window? The framing of the window curtains, the siding on the house, the sink or table, all help to make the image more interesting, they can provide balance, and it narrows down the viewer's selection to provide a more intimate setting for the pie to cool.

This concept of frame within a frame can be achieved with architecture, trees, people, clouds, lighting, or just about anything. It limits the view to just what is important. In a large print it can help keep the viewer from hunting and searching for the important parts. Pay attention for it when you watch a movie; guaranteed, you will see it being used. It could be the edges of a cockpit, or the frame of a doorway, or or trees in a forest. Below, Bob has come back to show us a common example of a frame within a frame. Here Bob is standing in a field waving. In the left picture he is alone; in the right, a tree creates a frame within a frame effect. The tree not only provides balance to Bob, but it also constricts the framing of the image to left and middle portions of the frame. Which do you think has a stronger composition?

Bob was also kind enough to pose for a very cliche frame within a frame image. Again in the first image Bob is just in a field, in the next he is in the

window of a house. This is probably one of the most common frame within a frame images that you will find in many text books. It puts the subject in context and narrows the viewers gaze.

# Leading Lines

Once the center of attention, or focal point, of an image is found by your viewers, their eyes will want to look around the frame to see what else can be seen. Those eyes can move randomly or they can be told where to go. Our eyes naturally want to follow lines and arrows; we're just set up that way. If you see a set of power lines receding into the distance, your eyes will follow those lines. If there is an arrow on a sign, your brain will tend to look for something that the arrow is pointing to. If these leading lines are done properly, they will lead you to another object or another portion of the composition. They can keep the viewer's eyes in the work, constantly moving and viewing a variety of objects in the frame, or if the leading lines are not done properly, they can lead the viewer's eyes away from the work and out of the composition altogether.

Leading lines have been used in art for hundreds, if not thousands of years. The Renaissance painters and sculptors were famous for using them or perhaps even overusing them, in everything from architecture and paintings to statues and even furniture. One of my favorite examples is from the High Renaissance painter Pala di Fano in his "Annunciation" from 1497. The lines in this work are formed in the floor tiles, the bases and pediments of the columns, the colonnade, the walls; even the hands of the angel Gabriel help to lead your eye.

*Pala di Fano - "Annunciation" - Fresco - 1497*

In every portion of this image, leading lines point to the center of the painting where a stylized version of Mary the mother and ever faithful servant of God sits waiting. Her hands, head, and body posture then act as more leading lines that bring the viewer's eyes out of the center of the frame up to God and then back out into the rest of the room where more lines bring the viewer back to the center of the image. The circular pattern of leading lines that the viewer's eye follows is a complete unbroken loop.

While the lines in Pala di Fano's 500-year-old work are obvious, leading lines are often more subtle. But even subtle lines will draw the viewer's eye to a given point. Perhaps they will lead the viewer around the image in a loop over and over again. If they are not used correctly they can confuse the viewer or lead the eye out of the frame altogether. Understanding how to use leading lines will make your images stronger, and they will help your viewers understand what your photograph is all about.

In the image below were going to let Bob take a break, and we will use a landscape example to combine all the earlier mentioned rules. The focal point is the setting sun, but in this particular case, the sun is a muted color, so it's a bit less likely to attract attention on its own, and it's not at one of the four intersection points of the rule of thirds, so it's not going to be quickly noticed. It is on the top horizontal third line, and that's good; you should almost never place the horizon in the middle of the frame. Regardless of what is noticed in this image first, leading lines are what move the viewer's eyes to the focal point, and keep the attention there, on the sun. The road leads the viewer right to the sun. All of the trees make nice little arrows that point to the sky; once in

the sky the crepuscular rays of the sunlight also form arrows that lead and point to the sun. Once the viewer is at the sun, the spikes coming from the sun then form their own leading lines that encourage the viewer to move away from the middle and back into surrounding landscape where the aforementioned leading lines bring the viewer back to the center again. The mountains that hug the sun and the trees that line the road create a nice frame within a frame that hold the viewer's eyes to the image.

Keep an eye out for leading lines as you go about your day; you will find that they are everywhere. When you compose your image feel free to move your camera, or your subjects, around to take advantage of the lines you find in your environment. Sometimes those lines that do such a great job at pointing the way are less pronounced. The effect is the same but the lines become invisible. These invisible leading lines are called leading looks, and they can be just as powerful and effective.

# Leading Looks

Just like leading lines, leading looks will cause your viewer's eyes to move about the image. People are social animals, and as such we are all trained to tune in to other people's faces, to understand their expressions, and realize what they are looking at. Like an arrow, faces point in the direction that they face. When someone looks in a direction, we notice, and we try to figure out what has taken their attention. Their action of looking urges us to look as well. These leading looks can act as leading lines and they change the weight and balance of a photo. If the image is not balanced to account for leading looks, it will lead the viewer's eye right out of the image, and most of the time this is not what you want.

For the most part it is good to place the subject so that the eyes point inward toward the middle of the frame, not away and off the nearest edge of the work. Having a subject placed so that they are looking to the nearer edge of the frame as if they are looking out of the image rather than looking in, can create a feeing that your subject is trapped, or boxed in, and it will always cause an uneasy and disturbing feeling. Most of the time, creating an uneasy or uncomfortable feeling is bad, but perhaps that feeling of being trapped is what you want. Film directors like Alfred Hitchcock were famous for giving audiences a nerve-racking and unsettling feeling. Framing a subject so that their leading looks quickly urged the viewer off of the movie screen is

one of many tricks he and other film makers use to accomplish this tension.

Look at the next few images. The subjects are identical in each. The left image has leading looks that

are not well balanced. The right side is more properly balanced. Because the images are so close together they can actually effect one another; if there is more than one image on your screen, you may want to cover one up so that you can only see one image at time. This way you can get a good sense of how the image stands on its own.

Leading looks don't have to come from a face. We people like to anthropomorphize the objects around us; it's why movies like *The Brave Little Toaster* or *Wall-e* are popular. Our tendency to do this causes us to give names to cars and ships, and it causes us to attribute leading

looks to objects that don't have ability to look at anything. These types of leading looks can come from any animal or anything that moves, or points, or is able to be anthropomorphic.

In these next four images of the truck and then the skier, the left images have leading looks

that point out of the frame, and so the image is out of balance. The right images have their leading looks pointed into the frame and image has better balance. This type of thing will hold true with sports shots, wildlife photography, babies, even food photography. Treat leading looks just like leading lines, use them to strengthen and balance your image.

# Backgrounds

It happens to me all the time, I carefully compose an image, I think about weight, balance, rule of thirds, leading lines and looks, color, highlights and low lights, exposure, depth of field and ISO. I put it all together for a strong image, and yet something in the background messes it all up, becomes a major focus point, and the photograph is just not as good as it could have been.

Backgrounds can be boring or interesting, plain or complex, but a background should never become the foreground. How many times have you gotten your photos back or seen them posted on Facebook, and there's a tree or flagpole growing right out of the top of someone's head? Or perhaps there is a bright object that just steals your attention away from the intended subject. Maybe there is something with writing on it, like an exit sign or a billboard. Your viewers will find meaning in those words, even if you don't want them to. That ugly, unfortunate background becomes part of your composition whether you like it or not.

The trick with backgrounds is to keep them in the background. When a tree or flagpole is growing out of your subject's head, just move a bit to the left or right. Find a slightly different camera angle. If the background is too busy, try finding a new background, or put that

background out of focus with a nice wide open aperture. That good blur can make an otherwise distracting backdrop look rather nice. Underexposing or overexposing your background can be another great way to make it less noticeable. Also, don't be afraid to ask your subjects to move a few feet to either side. Trust me; they won't mind moving. Backgrounds can also add leading lines, or balance to your photograph. You don't always have to figure out how to minimize them, it is often times better to incorporate them into your composition. Getting that background right may mean that you will want to look around and do a little bit of scouting before getting your camera ready for that next great shot.

## Scout Your Location

This may sound like work that you just don't need to be doing. But for every good shot, at least some scouting is in order. It could be that a group wants a quick photograph at a party. Take a few seconds to look around you. Is the place where they are standing really the best place to make an image? How does the background look? Is the lighting OK? Do you have enough room to work? The odds are good that by looking around for 10 or 20 seconds you will find a better place to shoot -- or at least a way to fix the place you are already using. It's easy to overlook that drink on the coffee table or that fake plant that clashes with everything. Our brains are good at finding the information we need and then overlooking everything else. In real life, we filter out the drink, or we don't notice the plant; however, a camera will record all the stuff that you just don't want to see, and it will make it part of the composition.

I often shoot houses for real-estate. These houses have nothing in them, just walls, ceiling fans, carpet, and electrical outlets. I can tell you from experience that when you walk into an empty house, unless you're an electrician, you probably won't notice all of the outlets. When looking at a photo of the same room, however, all of a sudden, the outlets are everywhere. They are annoying little white dots that pollute the natural beauty of the home. Our brains remove them, or minimize them, but the camera records them, and they are obvious in a print. In like manner, that plastic cup or magazine left on the coffee table will do the exact same thing. Go on and move it out of your frame; you will be glad you did.

This kind of quick fix can make a big difference in your party photographs. For a more in-depth shoot, real scouting is required. When I shoot a wedding or any other major shoot, I scout it out the day before. I talk to the people who work there. I walk around. I look high and low for that shot, and I make a mental note of the beautiful locations and ugly spaces. Let's say it's time for the bouquet toss; if the location is not familiar, how will you know where to stand? How will you know where to place your lights?

The entire point to scouting your location is so that you can make a better image by being prepared. The best way to get a sunset landscape shot is to be all set up and ready to go before the sun goes down. If you are shooting landscapes, find your locations long before the lighting is the way you want it to be. Scouting your location is a great way to make your shots better.

Of course with digital photography it's not unreasonable to tell yourself that you can "fix it in post-production" or "I can edit that out." Perhaps you can. It is usually easier, however, to just shoot it right in the first place. Sometimes, 10 seconds of work when you shoot can save you an hour or more in the editing room. So remember: scout and scout again. Keep in mind the rules of composition when you look for your backgrounds and if need be, fix the environment by moving a few objects or changing locations. With just a little effort you can vastly improve your locations, backgrounds and compositions; above all though, don't forget to have fun shooting. Having fun releases dopamine, and because of that chemical boost, your brain just works better when you are having fun.

*Chapter 6*

# Lighting

For many, the Dutch masters like Jan Vermeer, Gerrit Honthorst, Frans Hals, and of course Rembrandt are among the greatest painters to ever grace the canvas with a brush. Part of their fame lies in their ability to capture life and intimacy with brushwork and glazing that is yet to be matched. But what truly sets them apart from their predecessors is their masterful use of light and shadow.

There is a truth given to us in Jan Vermeer's "The Milkmaid." This lonely stout maid of the house looks both tired and resolute in her late afternoon work as she prepares a bit of bread and transfers milk from an urn to a bowl. There is wisdom and humility in her face; both youth and strength are dignified in her aging arms as she goes forth with her household duties. Yet for all that it embodies this painting would be worthless if not for Vermeer's use of the warm sunlight that cascades through the window. The soft light that gently caresses its way from her right cheek to the darkness of her left sets this work apart from the hordes of mediocrity that was being churned out by the thousands in the mid-17th

*Jan Vermeer - "The Milkmaid"*
*Oil on Canvas - 1657-58*

century. Light is what dignifies and immortalizes this timeless painting.

Vermeer's light was not accidental. The well-lit painter's studio was chosen from all the other rooms in the rather large house specifically for its light and Vermeer loved his room. Many of his works contain this same window and same warm light. For this painting the maid is doing kitchen work in a studio in the upper quarters of the home. In 17th century northern Europe the

kitchens were downstairs. We know from other paintings done in the same room that normally no kitchen items were present here. Based on this we can come to the conclusion that this master's work didn't just happen; it was staged. If it were painted in the real kitchen, the light would not have been this angelic. It would have been dimly lit, dingy, and boring. Vermeer had all of the tools of a household worker brought to the third floor so that he could paint his subjects in the best light possible.

Photography, like Dutch paintings, thrives on planning, scouting, and most importantly, light. Without light there can be no photograph, so it stands to reason that better light makes a better photograph. Exceptional lighting can make an otherwise boring image into one that is cherished for generations. Most photographers, painters, film makers, and artists will tell you that lighting is the key to a successful image. What they won't tell you is that beautiful light is not quite as complex or as difficult as it would first appear. Like composition, there are a few tricks and rules that make lighting your photograph relatively simple.

## Quality of Light

When we enter a room in our homes often we turn on the lights; when we leave we turn them off. Light, however, can have many attributes beyond just on and off. Different types of light have different effects or looks. Each type of light can instill a different type of feeling to your work. Often, we call these varying appearances to light the "quality of light."

Light can travel directly from its source to your subject, or it can reflect off an object before illuminating your photograph. The light that you have to work with can be hard or soft, bright or dim, and it can come in any color of the rainbow. All of these attributes, or qualities, come together to create the lighting in your image. Sometimes you will be in control of the lighting; other times you will have absolutely no control at all. Most of the time, you will have at least some control over the light that you are working with. Making minor changes to your lighting can have a profound effect on the final outcome of your photograph, and there are a few basic tools that you can use to quickly enhance your scene, or change the quality of light that you have to work with. Many of these tools, you may already own, and most of them can be found for cheap if you know where to look. Later, I will point out a few ways to use household or at least cheaper lighting items that can save you hundreds, if not thousands of dollars when compared to pro gear.

# Hard and Soft Light

Perhaps the most basic attribute or quality that light can have is whether it is hard or soft. Have you ever noticed how evenly lit, shadow free, and "soft" people look when they stand next to a large window with indirect light shining through the panes? It is as if the light gently wraps around all of the features of their face and body so that no area sits deep in shadow or is especially highlighted in just one particular place. The light is even and soft; it is gentle and seems as though it fills the depths of every shadow so that everything is lit. This same kind of shadow-free soft lighting will also happen on a fully overcast day when the light from the sun seems to come from all directions at one time. The window and overcast day are both great examples of soft lighting.

With soft lighting, there are relatively few shadows and the light appears to fade smoothly as it wraps around the corners of a face or object. Now, contrast that shadow-free image with the light of a dark basement or garage, lit only with a single bare 100 watt bulb. This light casts hard shadows on the wall. The eyes of your subject look sunken in and your subject's nose casts a deep shadow across his face; every scar, wrinkle, and pockmark is on display, even exaggerated, by the tiny spot of bright light that comes from just one place in the room. Lighting like this can make even the most gentle person look raw, exposed, even sinister. This is an example of hard lighting.

Creating, working with, and modifying your light so that it is soft, hard, or somewhere in between is easy to do and each has its own advantages and disadvantages. The most basic thing to know is simply that the larger your light source is, the softer your light will be, and conversely the smaller your light source is, the harder your light will be. The built in flash on your camera is a very small light source, so it is a fairly hard light. Certainly the sun is the largest and brightest light source that we have, but because it is so far away its apparent size is quite small; thus the sun is another good example of hard lighting. When it is overcast, however, the sun is still the light source but it has been modified, the clouds scatter the hard light from the sun, and the light becomes very soft. Just as the clouds modify the light from the sun to make it soft, almost all light can be modified.

# The Sun or Natural Light

All living things on earth owe a debt to it. Without it, our planet would be a drab, cold lump of a rogue planet floating throughout the galaxy. It is the primary source of energy on the planet, and most cultural events owe their genesis to the location of the sun in the sky. Yet, for a photographer, the sun presents several challenges that must either be accounted for or overcome.

Because it is so bright and its extreme distance makes it appear so small in the sky, the sun will normally cast very hard shadows and produce very hard light, especially when directly overhead. At noon, sunlight has much less atmosphere to travel through, and therefore is even more harsh, bright, and direct than at dusk. Beyond that, when it's overhead, its normally hard shadows bear directly down on your subjects; if you are photographing a person this overhead hard light can make their eyes look sunken in, wrinkles look more dramatic, and because of the extreme contrast between light and dark, colors can look washed out and muted.

Beyond the problem of its hard light, the sun is constantly moving, or rather we're moving in relation to the sun, so the light you are working with is never the same. For its challenges, however, the sun can also produce extremely beautiful light. Sometimes it would appear that we are all predisposed to love the sun. There are times when entire cities can literally stop in their tracks if the sunset is just right. There are times when no man-made light can create that natural beauty in a portrait, or landscape, or still life the way our sun can. Knowing how to use the sun is an art and a gift; however, its secrets are easy to unlock.

To start, people generally look their best when the sun is no higher than about 45 degrees above the horizon. Shooting at the "golden hour" or about 30 minutes before and after sunset or sunrise can make a boring landscape look as if it were painted with golden pigments by a divine hand. The grays and whites come alive with colors that the best cameras, painters, and poets could only pretend to mimic at best. One of these days I need to make it to northern Alaska in the summer where that 60 minute window lasts for much of the day. With that kind of ideal lighting that lasts for hours on end, it would be a snap to get some really stunning landscapes of that vast northern wilderness.

Unfortunately photographic moments don't always happen when the lighting is predisposed by nature to be perfect. Most of the time, in fact, the light that we have is far from ideal. If you have to shoot at noon and you don't want your light to have that "noon time" look to it, you will have to compensate. A quick way to overcome those hard shadows that does not take much time or assistance to set up is to force your camera to use its flash to "fill in" the shadows.

**Fill Flash**

If you don't know how to tell your camera to use its flash, or "force" your flash to fire, your owner's manual will have information on that. The job of the flash in this case is not to illuminate the entire image, the sun will take care of most of that for you. The flash is simply there to fill in the shadows and make your subject pop out from the background. This will also work if your subject is backlit or side lit by the sun or any other light source. To use a fill flash make sure your flash is set to fire, the auto exposure should take care of the rest. If the flash is not bright enough or too bright try changing the flash setting to adjust the flash power. The goal here is to light up the shadows of the image so that you don't have that hard noon time look to your images.

If you have more time to set up, and especially if you have an assistant to help you or at least a light stand and some clamps you can also fill in those harsh shadows by bouncing the suns natural light back into the dark areas with a reflector.

**Reflectors**

I keep a few reflectors in my camera bag, and a really good one can get expensive, but they don't have to be. Anything that reflects light will work. When I was a student in film school we used white foam core or sunshades from car windows as reflectors. I know some people who have used cardboard painted with silver spray paint. For a makeshift reflector, I like the automobile sunshades that are collapsable with a twist, they travel easily and perform more like

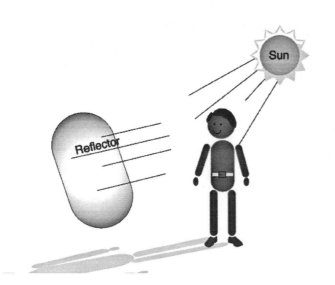

the pro gear than just about anything else on the market. Even now I will use some of those in a pinch. They are vastly cheaper than buying a pro-quality reflector and work nearly as well.

Bouncing light into your scene will work much like a fill flash. The light will fill in all those harsh little shadows and will help keep your subjects looking their best. While there is not really a wrong way to use a reflector, to start, try this setup about two or three hours before sunset. Place the

sun behind your subject. Have your handy assistant stand about 45 degrees to your right or left. Your assistant should play with your reflector moving it back and forth and moving around, standing in different spots to get the desired amount of sunlight reflecting into your subjects face so that the shadows are minimized. With your camera set to expose properly for the face of your subject, the sun that is behind her will act as a nice hair light. This is a time honored set up that is used in model, wedding, portrait, and fashion shots every day. If you don't want that sun over her shoulder or don't like that bright highlight on your subject, you can also move her into the shade of a tree or ramada, and still use a reflector or fill flash to brighten her up and make her pop out just a bit.

On an overcast day, the sun will not produce direct and hard light; the clouds will diffuse and soften the sunlight. This happens because the sunlight hits the clouds and scatters; the clouds then have a "glowing effect." Though the sun is still the source of the light, in a very real way, the clouds are now your light source; they have the appearance of being a much larger light source than the sun, so the light appears to be softer. This type of natural light is also cooler in color temperature than normal sunlight. Because the clouds go between the sun and you and scatter some light back up into space, the light that reaches you and your subject is also not as bright. Because the light is dimmer, if you are using a fill-light or fill-flash, you won't need as much power from your artificial light source to attain the same quality fill effect. Another benefit to clouds is, if you are using a flash on an overcast day, your flashes batteries will last longer since your flash is not working as hard. Because the light from an overcast day is softer, a reflector may not work as well as it does with direct sunlight -- although it will usually still do something.

Though the light from the sun is constantly changing its intensity, direction, and color, the sun is still one of the best light sources available, and for the cash conscious, sunlight is completely free and cheap to modify.

## Mixed Light & the Sun

Remember color temperature from the end of chapter three? Your camera's flash puts out light at exactly 6,000 K. The sun can range from 2,500 K or so at sunset to more than 6,000 K at noon, most of the time it is about 5200 K and if you place your white balance in the "sun" mode, 5200 K will be your camera's white balance point.

If you use your camera's flash as a fill flash when the sunlight is very warm, like at sunset, when the light is naturally fairly orange or has a low K, you are now using mixed light. The lighting in your image will have several different colors and perfect white balance will not be possible. This is not a bad thing. Sometimes it's rather great, but with mixed light you will have to white balance for one light-source or the other, not both.

If you color balance your camera for the flash, you are moving your white point to 6000 K and the sunlight will look even more orange than if you balance for daylight. If you balance for daylight, or the actual sunset color, the light from the flash will look quite blue. If I had the choice between the two, I would not pick blue people over an orange sunset, so I would white balance for the flash, the people will look natural and the sky will look orange.

If you don't want your subjects and sky to be vastly different in color, you can modify the color of the light from your flash to more closely match the color of the sunset by adding color corrective lenses called gels on to your flash. If you use a warming gel (such as color temperature orange "CTO" or perhaps a gel that is just a little less orange called a 1/2 CTO), this will modify the light emanating from the flash and cause it to be a bit warmer. Use the right gels and you can match exactly or at least get a similar color to the warm sunset. Then the light from the flash and the light from the sun will be relatively the same color temperature. You don't have to gel your lights to shoot people at sunset. I actually prefer not to; I like that deep orange sky that comes with our sunsets out here in Arizona, but if you don't like the color of the light coming from your flash, you can easily change that color or quality with a gel, and gels come in every color imaginable. This skill can be very useful if you are shooting an event like a wedding reception, and the lights are very warm. You may decide that you want your flash to match those warm lights as well, so you gel your strobe with a 1/2 CTO and white balance for the room. Either way these are all personal choices and there is not a "correct" way make this type of decision.

# Artificial Lighting

Of course, the sun is not the only light source that we have available to us. Artificial light is any light that is not from a natural source like the sun, and it comes with its own challenges and advantages. With sunlight you get whatever nature decides to give you; it's constantly changing, and difficult to accurately predict. With man-made light you gain both more control and more consistency. When it comes to photography, there are basically only two types of artificial light: continuous and strobe.

Like the name implies, continuous lighting stays on all of the time. Strobes on the other hand are on for just a fraction of a second and the light is gone. The flash on your camera is one very common type of strobe, and it's probably the one you will use the most. It is powerful, adjustable, and the color temp is always 6000 K. Since it is either built into your camera, or matched to your camera, the camera and flash talk to each other to give you fast and easy auto exposure, but it's not the only type of artificial light out there.

When it comes to artificial lighting, you have many choices: there are small battery powered speedlights like the one you use with your camera; then there are large powerful studio strobes, and of course there is continuous lighting. There are pros and cons to each and every type of light you use, but luckily the techniques for controlling, modifying, and using artificial light are very similar.

### Continuous Lighting

Strobes may be something reserved for the world of photography and special effects at night clubs, but continuous lighting is ubiquitous and does not have to be specialized to photography to be of use. There are many advantages to using continuous lighting. To start, since they are always on, you don't have to figure out a way to trigger a flash when you take your photo. They are also quite convenient in the sense that you can see the effects of the light while you set them up, position, adjust, and modify them. They also serve double duty; if you want to make movies, continuous lights can work for both still and motion pictures, and set up is the same. Every advantage comes with a disadvantage, and continuous lighting has many. They produce heat; depending on the type of light bulb you are using they can produce a lot of it. They are also nowhere near as bright as strobes, and they use much more electrical power.

If you are shooting in a home, each circuit can only handle 15 amps before you blow a fuse or circuit breaker. A normal studio light is 500 to 1,000 watts. Typically we call 1,000 watt lamp a 1k. Amps x volts = watts, so if you live in the USA where your wall outlet ranges from 110v-120v your amps formula will look like this for a 1k: amps x 110 =1,000, so amps = ~ 9. This means a 1,000 watt studio light pulls 9 amps from your wall socket. Plug in just 2 of those and you will blow a breaker.

When I worked in the television industry, power was a constant concern. If we wanted to shoot an interview in someone's home it was often a challenge to get the lights set up in a way that worked for our needs and didn't burn the house down. Modern lights are less power hungry but they still need a lot more power than a small speed light or even a large studio strobe to light the same set.

### Strobe Lighting

Unlike continuous lighting, strobes are on for an instant and then they are off again; in that short time that they are on, they create a lot of light. They do this by collecting and storing electricity in a device called a capacitor. When the strobe is told to fire, it releases all of that energy into the flash tube to light up the room and expose your image. It is as if they take all of the power that a normal lightbulb uses in 2 or 3 seconds and release it in 1/2000th of a second. As a result, they use much less power to deliver the same results.

Because they are on for just a moment, however, they are not suitable for motion pictures or video. They really are good only for still photography. Also that momentary on-off nature introduces another problem; you cannot see what the light will look like when you do your setup. Luckily, we live in a world of instant feedback so you can do a lot of guessing and check with your DLSR and your strobes. These two downsides are really minor, and strobes do a great job. They are efficient, easy to use, and the light is easy to modify. There are two basic types of strobes: speedlights and studio strobes.

### Speedlights

Speedlights are small flashes that fit onto the hot shoe of your camera. They have internal batteries and may have an option for external batteries as well. Because of their compact size and built-in power source, they are great for on-location shooting. I keep three of them in my camera bag and I can handle many lighting situations with just those lights, some stands, and a few

lighting modifiers. Perhaps one of the best things about speedlights is that most of them have auto exposure capabilities. This gives you the freedom of not really having to think too much about the output settings on your strobes. Auto exposure also means that your strobe can adjust to changes in the ambient light or changes to your cameras settings for you.

Your camera and flash use TTL *Through The Lens Metering* and sometimes some metering built into the flash to come up with proper exposure. With TTL your flash will communicate with your camera, and together they decide how much power to produce. If there are several flashes in your setup all using TTL exposure technology, they may all communicate together. Most of the time this is great. Just like using TTL without a flash, TTL with a speedlight flash is fast, convenient, and simple to use, but there are some things that can cause your camera and flash to get confused. Remember 18% grey or middle grey? When the subject, or background, of your photograph is much darker or lighter than middle gray, your camera will misunderstand what it is exposing for and your image will likely end up under or overexposed.

You already know that you can tell your camera to correct its exposure by adjusting the auto exposure bias. You can also correct for this with the flash power exposure bias. You will have to read your owner's manual to find out how this is done on your camera. On my camera, it can be adjusted both in the camera and on the flash with a quick push of a button and click of a wheel. If your background looks good but your foreground is over exposed, try lowering the exposure bias of your flash. If the flash looks good but the background is too bright, try lowering the exposure bias of your camera's exposure. If both are correct and you change one, you may have to compensate by adjusting the other in the opposite way.

One of my absolute favorite things to do when shooting outdoors is to underexpose the sky but still have my models properly exposed. This is very easy to do when shooting in full manual camera and full manual flash modes, but it is also very easy to do using full auto exposure with TTL. You just have to trick your camera a bit. Here is what I do: I tell my camera to underexpose the image by about one stop or sometimes 2. Then I also tell my flash to overexpose about one or two stops. Sometimes I have to make some minor adjustments after I take my test shot. The net result is that my subjects have proper exposure and sky and background are underexposed by about a stop or two. This introduces drama and adds a level of impact that the photograph otherwise would not have had, and it's a popular look.

This image was taken with a single on-camera flash using the above method. The settings were ISO 250, f/10, 1/200 sec, 16mm. The TTL auto exposure bias was set to underexpose by 1 and 2/3rds stops or almost 2 full stops. The flash TTL power exposure bias was set to overexpose by about 1 and 2/3rds stops, the end result is that the entire image would have been underexposed by nearly 2 stops, but everywhere the light from the flash landed was brought back to proper exposure by the overpowered strobe. So the sky, where the light from the flash could not reach is still dark, while the car and mechanic are properly exposed. The only way to get more drama from a photo like this would be to get the strobe off of the camera all together; luckily that is not too hard to do these days and we will go over that in just a bit.

*Jason Youn 2010 Canon 40D 16mm
ISO 250 - f/10, 1/200,*

Automatic TTL and automatic TTL with exposure bias adjustment are of course not the only way to shoot. Automatic TTL is a powerful tool and I rely on it often, but no computer can calculate art. With the flip of a switch you can change to full manual mode and have complete control over the light output. You then adjust the power output of your strobe just like you control all other exposure settings, by adjusting the stops.

Another great advantage to speedlights is that they can be taken off of your camera with ease, and you can use more than one to get the lighting effect that you want. FYI, almost all speed lights on the market create light that is 6000 K so matching one light from one brand with another light from a different manufacturer is normally not an issue as long as you don't need them to communicate with any advanced TTL languages.

### High Speed Sync

Another great feature of TTL strobes is something called high speed sync. All cameras have a strobe sync speed. This speed is the fastest shutter speed that your camera can have when using a flash. For most crop frame DSLR cameras that number is 1/250th of a second. For most full frame cameras that number is 1/200th. If you try to take a picture while using a flash at a shutter speed faster than that, like say 1/500th, you will run into a problem: not all of the image will be exposed.

This problem occurs because of how your shutter is designed. DSLR cameras use a shutter that opens, then closes. But it does not open in the same way that it closes, like a door on a hinge does. When you make an image your shutter opens on one side, then closes from that same side again as if a curtain that conceals a stage is opened from left to right, then another curtain closes the stage again from left to right. This is done so that no part of the image sensor is exposed for a longer or shorter time than any other part of the sensor.

Your strobe light is timed to go off when the first curtain is open all the way but before the second curtain closes. This way the entire sensor is exposed to light, your strobe then fires, then the next curtain closes. If you have a long exposure your strobe has a long window to fire. If your shutter speed is right at the sync speed limit, the timing must be exact.

Now for the fun part, if your shutter speed is too fast only part of your image sensor will be exposed to light when the flash goes off because the second curtain will begin to close before the first curtain finishes opening. Or in other words if you are making an image where the shutter speed is faster than the max sync speed your shutter is never open wide enough to expose all of the sensor at one time. If your shutter speed is very fast like 1/4000th then the first and 2nd curtain will only be a millimeter or so apart, the image will be exposed with a line of light, almost like a flat bed scanner scrolling across a document.

So then how can you use your flash if your entire sensor is not available to collect light when the flash goes off? This is where high speed sync comes into play. Your camera and some flashes are so good at talking to each other that your flash can actually pulse very fast -- so fast, in fact, that to you and me, it looks like one burst of light, but it's actually many quick flashes. The result? Even though your sensor was not ever fully open, it still gets proper exposure across the entire image.

Why do you need this? Well, good question. It's all about making the image look the way you want it to look. Let's say your settings are such that your camera needs to be at f/5.6,

ISO100, and 1/800th and you want to use a strobe as a fill flash for your model. You can't. 800 is 2 stops faster than your sync speed. So to use a strobe you will need to move your settings to 1/200th, to make up for this 2 stop gain in light you will have to change your aperture to f/11 and now your depth of field is much larger than you wanted it to be. Unless you use High Speed Sync, now you can make your image the way you want without sacrificing your depth of field.

Now for the downsides, because speedlights are battery powered, you may have to change batteries several times throughout a long shoot. Speedlights also have limited power output capabilities. They are fairly powerful and most of the time they are all that you need, but if you are shooting large groups of people, especially on a bright day, you will probably want more power than even the best speedlights can manage. Beyond that, however, the downsides to speedlights are few. They are great little lights and I love working with mine.

**Studio Strobes**
Studio strobes, on the other hand, can produce a lot of light. These are the big lights you see at the pro studios. Just like speedlights, they are on only for a moment, but since they do have some lower power continuous lightbulbs built-in called modeling lights, you can see what you are doing with your light while you create your setup. Studio strobes also have many options for modifying the light that is created, and since they plug into the wall, you don't normally have to worry about batteries. On the downside, they are bulky and heavy, they have to be plugged into a power source, like a wall outlet, a generator, or an external battery pack and you usually have to buy a radio trigger setup to get the flashes to fire when your camera does. There is also no TTL. When you shoot with studio strobe lights you are shooting in full manual mode only. Since there is no TTL communication with these lights there also usually no high speed sync. Though there are now some large studio strobes out that can manages TTL and high speed sync, this is currently not the norm.

These downsides are minor, and if you have space for a studio, these are the way to go. Their light is beautiful, powerful, and easy to work with. There is much more that can be said for studio strobes and I would recommend getting a book or video specifically created for studio strobe instruction. Better still, you can take a class at your local community college dealing with studio lighting if you think this type of photography is for you. I have taken some of those classes and they can be both a fun and informative spring board to get you going, though nothing

can make up for practice and experience. Having said that, when I got my first set I just purchased a cheap one online and started playing. It was not until much later that I ever took a class on using studio strobes.

For all of the differences that exist with artificial lighting, the principles of lighting your set with studio strobes, continuous lights, or speedlights are almost identical. There are thousands of items on the market that soften, diffuse, or change the color of your light or create light patterns, and sometimes these light modifiers are interchangeable from one type of light to another.

## Modify The Light

Adjusting the way your flash creates and directs its light is a great way to set yourself apart as a real photographer and keep your photographs looking fresh. Perhaps the most basic thing you can do to make your on-camera speedlight flash more interesting is to bounce it off of a wall or the ceiling. Having a flash on your camera is nice, but the light comes directly from your camera, bounces off of your subject, and comes directly back to your camera. The result is that your image can have a flat look, especially if the flash makes up the majority of the light required to make your image. If you turn the flash up or to the side, the light will bounce off of a wall, the celling, or anything in the room, that light will be diffused, softer, and not so direct. It will also take on a color cast of whatever it bounces off. If you bounce the light off of a red wall, your light will come back warmer; if you bounce the flash off of a blue wall, your light will come back cooler. (If you are using the built-in pop-up flash from your camera, you probably

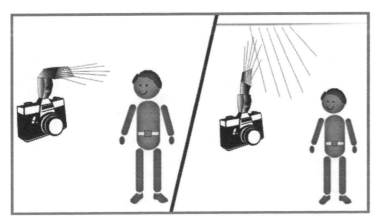

will not be able to bounce light; it will most likely have to be a flash that fits onto your camera's hot shoe. However, there are some light modifiers on the market to accommodate those built-in flashes, and if you don't want to buy a big on-camera hot shoe flash, check into some pop-up-flash light-modifiers. )

Along with bouncing your flash off of the ceiling or walls, there are several tools that are sold at your local photography shop that modify the way the light comes out of your flash. Some of them diffuse the light, some bounce it, others act like a soft box, or a beauty dish, and make your light source larger and softer. It is worth taking the time to check into what some of these modifiers do. I keep several kinds in my bag. One of my go-to diffuser is a little foggy white box that attaches to the top of the flash. This helps to diffuse the light so that some of it scatters around the room and some of it is directed at my subject; it also makes the light source just a little bit larger so the light is just a bit softer. It only costs about $15 -- not a bad price to soften the quality of a strobe. Another thing I keep on hand is a little soft box that velcros onto the front of the flash. This makes the face of the flash about 3 times larger, so it softens the light a bit. I also keep a set of cheap gels in my bag. They just velcro onto the flash and change the color of the light from the flash. I have two sets, one is used for color correction, and the other is a set of bold colors for some outright fake colorful looking lighting.

All of these lighting modifiers are fairly cheap, fold up small for my camera bag, and fit right onto my flash. They all have one goal, to keep my images looking better than a typical on-camera flash shot. One cheap and easy trick that many event photographers use is a clear plastic cup light modifier. Find a clear or foggy plastic cup, the bigger the better. Place it upside down over the flash so that the light fills the empty chamber of the cup and secure it in place with some tape. Point this flash up as if you are going to bounce the light off of the ceiling. The cup will light up and become your light source. The result will be a two-fold deal. One, your light source is larger so the flash will be softer, and two, most of the light will bounce around the room, so you will also get the effect of a bounce flash. This is cheap, easy, and a good thing to know when you're in a bind and you forgot your other gear.

If you really want to keep your flash from looking like a typical on-camera flash, however, you can actually take the flash off your camera and even use more than one.

# Off-Camera Flash

A great way to keep your image from having that flat look that can come from the on-camera flash is to take your flash off of your camera. You can add more than one flash to your system, and this does not have to cost a fortune. There are several speedlights on the market that do not have TTL; they work in manual only. They are usually off-brand gear, but not always; they work great, and you can pick them up for relatively cheap. If you want to get into a multi-light set up, these cheaper speedlights can be a good way to go. You will need a way to trigger the flashes, but this does not have to cost much either. You can trigger them with wires or optical slave cells. Better yet there are also some good quality cheap radio triggers on the market. You will need a transmitter on your camera, and a receiver for each speedlight. Depending on your flash and camera set up, you may already have everything you need. Depending on your gear, a wireless flash system may already be built into your camera and flash(es), or you may have to get a little communicator device that sits atop the hot shoe of your camera. Check your camera's manual or ask your local camera shop about this. No matter what method you used, you will need a way to trigger your flash when it is off of your camera's hot shoe.

All of the information for this section about light setups is actually the same for speed lights and studio strobes, and the info and principles are very similar to continuous lighting. A typical one light set up would have the flash off of your camera and mounted on a light stand just above and to the side of your camera. If you can, give this a try, move the light around and see how the location of your light changes your photograph. The closer your flash is to your subject the less power output you will need. So if you move your flash closer to your subject, you will need to bring the power down. Or if you can't get enough power output from your flash, you can move it closer to your subject.

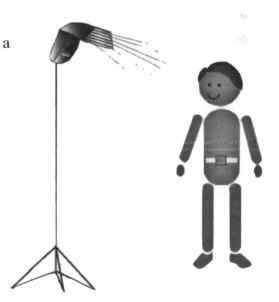

When you move your flash off of your camera, you gain the option to use soft boxes, umbrellas, and other light modifiers that would otherwise be way too large to use while the flash is on your camera. On-camera flashes have a very small light source, so the light is just going to be hard. By using an umbrella and an off-camera flash on a light stand like in the next image,

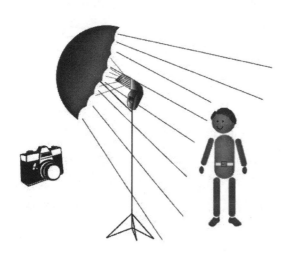

your light source will essentially become the size of the umbrella; if your umbrella is 25 inches wide, your light source will have gone from being about 6 square inches from a bare flash to almost 2000 square inches when that flash is bounced off of an umbrella. That's over 333 times the surface area. That kind of increase in surface area means that your newly modified light will be much softer.

Another great advantage to moving your strobe or speedlight off of your camera is that you now have the freedom to add more flashes. Most setups are 1 to 4 flashes but from time to time, people do use more. If you know your way around your camera and you want to play with some more complex flash setups, I would recommend having at least two flashes on some stands with umbrellas. It is best not to even think about 3 or more flashes until you get comfortable with just one or two. Start with one and get that working the way you want, then add the second. To make things easy, each light has a name. There are hair lights, back lights, fill lights, rim lights, background lights, and the list goes on. These names don't refer to the type of light or light modifier used, rather these names refer to location, purpose, and brightness in relation to the other lights. The primary light in any scene is called the key light.

### Key Light

If you have just one light, or if you have several lights, the primary light is the *key*. This is normally the brightest but from time to time, may not be. In the previous image the key is a strobe with an umbrella to diffuse and soften the reflected light; there is no other light used. Keys are often placed about 10 to 90 degrees to the left or right of the camera. If you only have a key light, you will most likely create an image that displays very pronounced shadows since there is not another light to fill in those shadows. To get rid of those shadows, or soften the shadows created by the key light, people often times add a fill light, so it should be no surprise that the next most common light someone might add to a setup is the fill light.

### Fill Light

As the name implies, "fill lights" fill in the shadows caused by the key and provide more even lighting throughout your photograph. You don't need to own two lights to shoot with a fill. You can create a very effective fill light with just a key and a reflector. Not only is this an effective and cheap way to go, but it is also popular even in studios that have access to all the lights they need. The quality of the image that you can make with one flash and one reflector is

actually very high. The set up is easy, and the gear is easy on your budget. The next image in this book shows a fill and key. The left portion shows a key light and fill reflector, the right shows a key light and fill light. Both will produce stunning results and both are fairly easy to use. In each case the fill light will likely be about 1/2 the brightness of the key, or one stop less.

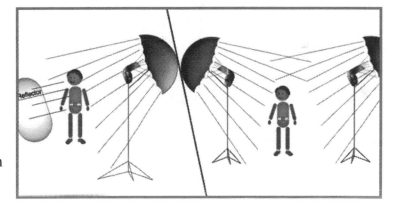

For an easy home studio, try this: on the left side of the next image is a very common way to create a key fill set up. Place a speedlight, studio strobe, or continuous light high and to the right of your subject. Use an umbrella or soft box or even just the bare lamp, each will look a bit different. Get your key set the way you want and then add the fill reflector. Place your reflector low and to the left of your subject. The idea here is to bounce the light from your key back into

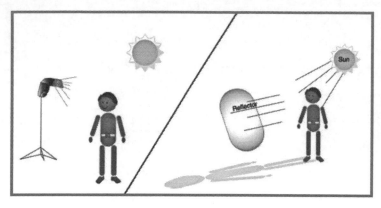

your subject thus filling in the hard shadows with soft light. If the fill is not bright enough, move the reflector closer to your subject. If the fill light is too bright, move it away. Try different angles and positions for both the key and the fill. As you play with these two lights, try to remember the results of each change.

If you shop on a budget, you can get a cheap strobe and trigger for less than a hundred bucks, a stand, mount, and umbrella for another $50 to $80, and a reflector for around 30 bucks. Or you can get even cheaper by using a scoop lamp from the hardware store and a very bright bulb. Clip that onto anything that will give you the placement that you like; a stepladder works just fine. Use your car's sun shade as a reflector, and now you have a studio set up for about $20. Of course the cheapest light in the world is our very own sun. You can easily use the sun as your key light and a strobe or reflector as a fill light.

## Lighting Ratios

This next short section is probably something that you will not have to worry about or think about unless you are doing studio work with other people who also know what they are talking about, and expect you to speak the same studio jargon language. If you are only working by yourself than the, "that looks just about right" method for lighting will probably suit you just fine. If you want to describe a setup or instruct an assistant, or if you want to be an assistant, it is a good idea to know how to speak the photo language.

The relationship of the brightness of one light in comparison to another is called a lighting ratio. You already know that we measure exposure and light levels in halves and doubles of brightness, or stops. The amount of power that a flash creates is normally noted as full power or 1/1, half power or 1/2, and so on for the entire range of the flash. Most flashes go from full 1/1 to 1/32nd power, or 5 stops of power give or take a stop or two.

For light ratios we are not talking about the power of the flash, rather we are referring to the brightness of the light when it hits your subject. If your model's face is twice as bright, or one stop difference, on one side vs. the other, the ratio is 2 to 1. If there is a 2 stop difference, or it is

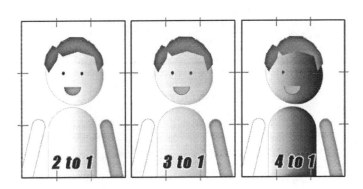

4 times as bright from one side to the other, there is a 3 to 1 ratio, and if there is a 3 stop difference (8x brighter) it is a 4 to 1 ratio. If the subject is evenly lit the ratio is 1 to 1. The higher the ratio the more dramatic the difference will be from one side of your subject's face to the other.

## Multiple Lights

While it is easy to create high quality lighting with just one or two lights, having a few more lights can help you to fine tune your image. This may sound like a tricky thing to do, and it can be. You don't need tons of pro lights to do pro work but knowing how to use more than just one light is a great skill.

Remember to go slow and add lights one at a time. Don't just jump into a ten light setup. Start with one, and then go to two and so on. If something looks wrong, test each light one at a time to see where the problem is. Keep your set up as simple as you can. If you can use two lights to do the job, you probably should not use that third or fourth light. Although one or two is

usually all you will ever need, sometimes the only way to get the shot you need is to use more. If you find yourself wanting to really get into studio lighting in big way, get ready to spend lots and lots of money. Though I started out with cheap stuff like $8 scoop lights and poster board with silver spray paint, I quickly upgraded to better gear. I would also recommend taking a studio or commercial photography class. You can learn a lot from a class and the other people in it, and you get to play with lots of high-end lights before you take out a second on your home to pay for it all. For a quick intro, however, I have included a very common lighting setup in the next image.

Below is a top-down view example of a common four light set up. The key light is your primary light. All of the other lights will have their power output based on the brightness of the key. The key can be positioned in several places. Here we have it at about 45 degrees from the camera. The fill light is about half the power (for a 2 to 1 ratio), and is on the opposite side of the camera. The backlight is normally a similar power to the fill but could be brighter or dimmer depending on the look that you want. It helps separate your subject from its background, and can create a nice glow around your subject's edges. The background light keeps the background from falling off into darkness and can be used to make the background more interesting. It is whatever power it needs to be to gain the desired effect.

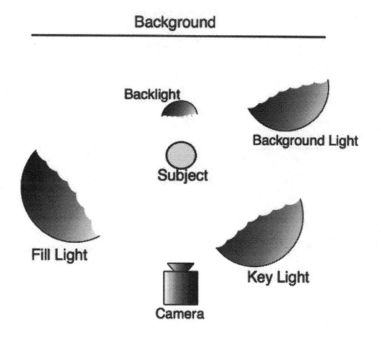

You don't need a set up this big to get professional results, but it is always fun to play with new tricks. This four light configuration is a time honored set up in both still and motion picture production.  You have no obligation to stick with these lighting formats; they are just starting points. Play with your lights and have fun. Don't be afraid to try new things. All of this takes

time to learn, and practice is important. If you find something you like better, go with that. Lighting is not only a science but also an art.

I have mentioned using cheap alternatives to pro gear. It took me a while before I started lighting my sets with professional equipment, and even now I don't use the most expensive stuff. When I was still in film school we very often used work lamps from the hardware store, and those little things did a good job. If you want to go that route, great. There are some tricks to make those lights look better. You can modify the light from them with just about anything from your home. The light can be diffused by bouncing it off of some white poster board, or shining it through a translucent white shower curtain to create a soft box. I have seen pro-photographers use all of kinds of creative things to light a room. Even though these tools are often quick and cheap, the results look professional, and most of the time the viewer of your final image will never know the difference. Though there are many rules to lighting, rules were made to be broken. Feel free to experiment, and try new things.

*Chapter 7*

# Common Tips and Tricks

So much of this book has been made of hard facts and rules of science, art, and cameras. While I am kind of a geek and find all that stuff fun, I recognize that most people don't. Photography is about getting out there and seeing the world in your own way. It is about challenging yourself to try new things, go new places, meet new people and push yourself both physically and mentally. Along the way you will learn more about your gear, your art, and yourself. As you go you will probably find ways of doing things that some people will agree with, and you may find some tricks and techniques that will leave many people scratching their heads wondering why you would ever do something the way that you do. This next section is all about those little bits of life, technique, and style that I have picked up along the way. I hope some of it helps you with your camera work as you go out and see the world through your own lens.

## What's in Jason's Camera bag?

Sometimes deciding what to bring and what to leave at home (or what to buy) can be harder than actually making your photograph. To make matters worse the things you want in your camera bag may be different from one shoot to the next. Bring too much stuff and your bag will be way too heavy, and it could be hard to cram all of that stuff into just one bag. On the other hand it really sucks when you need a piece of gear and you left it at home. When I was first starting out, this was not much of a problem as all of my photo gear could fit in just one bag, and that bag didn't really weigh that much. If you are geek like me, however, your gear will outgrow your bag, or even bags, and then it's decision time. What will stay on the shelf and what will go to the shoot? The first question you have to ask yourself is what kind of a shoot is this? If you are shooting wildlife, your bag will look different than if you are shooting a wedding.

For landscape photography I try to pack just what I will need and not much more. I can't take all my gear if I want to be able to walk a few miles down a rocky trail and still have enough life

left in me to make a successful image. So to start, I have several camera bags to choose from, for landscapes I take my camera backpack. It's versatile, easy to carry, and if I had to own just one bag, this would be it. In the bag I of course have my DSLR camera, and I have some lenses from which to choose. Most of the time I like to shoot landscape with a wide angle lens, but I keep a long and a normal lens in my bag as well. The long lens is great because it allows for another take on a landscape environment that may not otherwise be discovered; it will compress the foreground and background and display a world that we would not otherwise see. Beyond that, you never know when a landscape shoot will become an impromptu wildlife shoot, and animals don't normally like to get right up close to photographers. If I know I will be shooting wildlife, I also bring a monopod. Monopods are like tripods but they only have one leg. They are nowhere near as stable but they are very fast for grabbing a moving target and acquiring your focus and composition. I usually leave the flashes at home for landscapes but sometimes I will take just one.

Among the most important things that I bring for landscape work is a good solid tripod and an off-camera shutter release button; these buttons are so small that I leave one in my bag almost all of the time. For the tripod, when it comes to landscape, the more rugged the gear, the better. A water bottle is a must (I love my Camelbak). Digital photography has almost completely gotten rid of the need for filters, but a polarizer filter is still of some use and is good for reducing the contrast between the bright sky and the landscape.

For a wedding or engagement shoot, on the other hand, I have to pack a lot more gear. I also like to bring an assistant to make things easier on myself. Along with all of the stuff that I take for a landscape shoot I also bring several flashes, some reflectors and diffusers, some light stands, sand bags, soft boxes, baby wipes, and some external batteries to help my flashes work faster and last longer. To take all of this stuff, I have to leave my comfy backpack behind and use a larger camera bag and some other gear boxes.

For every shoot, I keep some tools in my camera bag. Along with my normal camera gear, I have a multi-tool with pliers and knife (or sometimes two) in my bag; I also keep a flashlight, lots of extra batteries for all of my gear, gaffer's tape, clamps, Sharpies and pens, a note pad, extra memory cards, camera cleaning supplies, a handkerchief, extra camera plates for the tripod, business cards, and perhaps most importantly, a granola bar. It's hard to shoot when you're thinking about food.

Packing the right gear will definitely make your shoot go more smoothly; not bringing gear you don't need will definitely save your back. The most important thing is, of course, the camera; from there I try to think of what I need and leave the rest at home. Because each situation is different, my bag often looks different and that's ok.

**Camera bag recap:**

•Plan ahead for the shoot you expect, bring the gear according to that plan.

•An easy to carry camera bag is a good starter bag, backpacks are great.

•If you don't own a lot of gear, bring it all.

•If you can't bring it all, bring what you need and ditch the rest.

Good Thing to Bring:

•Camera or cameras

•Lenses

•Flashes and flash accessories

•Off-camera shutter release button

•Tripod

•Polarizer and ND filters

•Multi-tool

•Flashlight

•<u>Spare Batteries</u>

•<u>Extra Memory Cards</u>

•Gaffer's Tape, clamps, and other grip gear

•Sharpies, pens, and a notepad

•Camera cleaning supplies

•Handkerchief

•Spare camera plate for your tripod

•Business cards

•Water and energy bar

# Portraits

We humans are perhaps the most photographed subjects on earth. We love images of each other, our families, our friends and loved ones -- people. Images of those whom we care about are almost the only instances when a truly bad photo is still cherished by the viewer, not because of its photographic excellence or the inherent beauty of the image, but because the picture represents someone close to our hearts. So if even a bad photograph can be a great treasure if the image is of a loved one, imagine how much more valuable an image of someone close to us can be when it is well shot and beautiful in its own right.

Like so many other subjects in photography the keys to a successful portrait are lighting, exposure, and composition, and like so many other compositional situations, the rule of thirds is once again king.

*Jason Youn 2012 - Canon 5D MKII - 54mm*
*f/5.6 - ISO 100 - 1/125 - 3 speedlights*

To the left, all three aspects work together to make a technically good image, combined that with the simple truth that this baby is loved and you have the makings of a photograph that will be cherished. For the subjects composition, the child's body is on the left thirds line. The bright red portion of her jumper and her smiling face are near the upper left thirds intersection, and the rungs of the ladder create leading lines that point to the girl's head. The background is simple and dark, contrasting all of the bright portions of the image so that they stand out. The exposure is correct, and the quality of light is soft. For the photographer, so many of the rules of art come together to make this image, but for the viewer, it's simply a beloved photo of their toddler learning to walk.

*Jason Youn 2011 - Canon 5D - 175mm*
*f/3.5 - ISO 100 - 1/60 - Studio Strobes*

For a simple and time-honored portrait composition that works well to create a great portrait of one person, place your subject's eyes on each of the top third intersections; make sure the lighting is soft and your exposure is right, and you will have a decent portrait. You may remember this next illustration from earlier in the book. Notice how Bob's eyes are each on the third intersection in the photo on the right, but not the left.

This is a classic example of good portrait framing; it is formulaic and common, but it's common because it works. What you don't see in this illustration is how different focal length lenses and different apertures can make or break an image. If you are doing environmental portraiture, where the location is just as important as the person in the image, these next tips won't do you much good, but when all you care about is the person in your image, then copy this formula exactly and you will have a great photograph that will be loved for generations. As you get good at the formula, then try changing some things up here and there and see what happens.

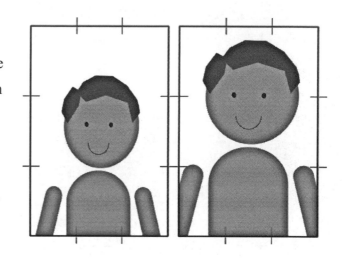

You have the first step: the desired composition. Next comes the camera settings. To keep your subject isolated from the background, and add depth to your photograph, you will want to use a shallow depth of field. This means a fairly wide open aperture. F/5.6 or better is good. I like to shoot these kinds of portraits at f/2.8 or even wider. Next consider how lenses distort an image. If you use a wide angle lens, a person's face will look different than it will with a long lens. While a normal lens will yield a relatively normal representation of your subject, something nice happens when you photograph a person with a long lens. The way a person's facial features are reproduced with telephoto glass is pleasing. For this reason, I oftentimes like to shoot portraits at 85mm or more; sometimes I even shoot at 200mm and it produces great results.

Finally, consider, of course, ISO and shutter speed. In this case these two things all come down the fineness of the grain and crispness of the image. Choose the lowest ISO your situation will allow and the fastest shutter speed you can muster. Try to pick a shutter speed that is at least twice as fast as the 1/shutter speed rule if you can. So if you are shooting with an 85mm lens on a full frame camera, shoot at 1/200th of a second or more to make sure your image is very crisp. If

you need to sacrifice on shutter speed and ISO a bit, that's ok. The better you can do with these two settings, the sharper and cleaner your image will be.

Now that you have a long lens, wide-ish aperture, low ISO and a fast shutter speed, select your focus point (I like to focus right on the middle of the eye of my subject). Compose your image and create your photograph. Try bracketing your exposure and take your photo again. I have found that many times, and especially when I am outside, an image that is 1/3rd stop overexposed works well for portraits. If the subject is backlit, a full stop or more overexposed is usually the right choice. You may find that this is not true of your work depending on several things including how your camera's light meter is calibrated and what you like to see in your work.

These next two images are of the same person, with the same framing; one has a wide angle lens and small aperture, the other has a long lens and wide open aperture. Notice how different the two images are, even though the location, subject, framing, lighting, and camera are all identical.

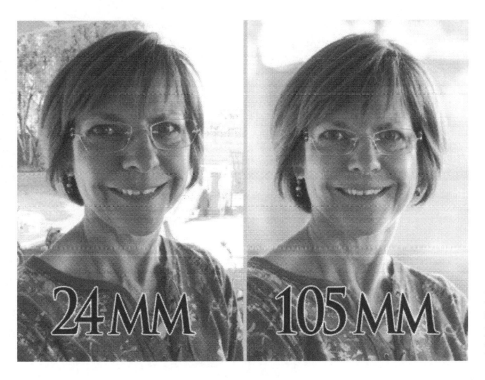

Both images:
Canon 60D, 24-105 f/4 L
Left image: 24mm f/16
Right image: 105mm f/4

For group portraits, the rules change a bit. To start, the composition will change since you have to fit more people in the frame. Still try to use the general rules of art. If you have two people in the shot, try placing each person on the vertical third line, this works well for balance if the two people are similar in size, if they are vastly different in size you may need to adjust your composition to help balance out the frame. Because having multiple people in the frame will make it unlikely that your subjects will all fall on the same focal plane you will need to have a larger depth of field. I noted that f/5.6 was about the smallest aperture you would want for shooting just one person. If you are shooting several people in a group, f/5.6 would be about minimum, f/8 or so would be better. If your depth of field is too small for a large group you will have some people in focus, and others out of focus.

**Portrait Recap**

•Use the rules of art.

•Use a long lens when you can.

•Use a wide aperture when possible f/2.8 or 4.

•For large groups constrict the aperture to F/5.6 or 8.

•Use a low ISO and a fast shutter.

•Bracket exposure.

# Landscape Photography

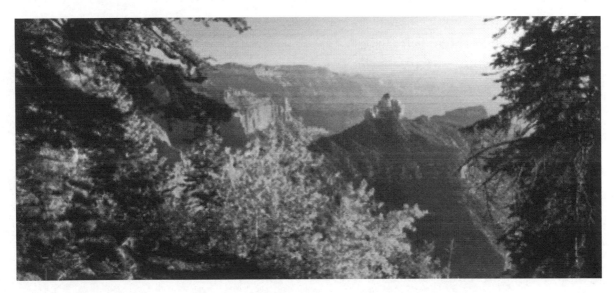

If you ask someone to name a famous photographer you will likely hear about Ansel Adams, and while he actually shot all types of photography, was involved in several organizations, and lived a diverse life, he was most famous for his landscapes. His work helped to raise awareness of the vast American wilderness that lay unseen by much of the nation. His photography sells for large sums at auction and remains as relevant today as it did decades ago when he first created his iconic black and white images. For all of this, however, Adams was not the first to photograph the wild, and according to some he is not the best either. So what does his work have that the others don't? Well, in some cases it is simply about marketing, but for the most part what sets Adams apart is that his images have a profound impact on his viewers.

So what is the most important aspect to any landscape photograph? Impact. Not every image will impact everyone. Some landscapes just speak to certain people and some don't. If your viewer grew up in the Rocky Mountains and misses his home, even a bad photo from the region could be cherished by that person. But a bad photo won't impress many people at all. To really reach out with your work and get the kind of shot that makes people say wow, to make an image with impact, you can use just a few simple tips and tricks. When it comes to landscape you can make sure you have impact with location, composition, camera work, time of day, and lighting.

## Location

Location, of course, is a big part of a landscape image. After all, the subject of the image is the location. A good photographer will be able to create a decent landscape photo anywhere, but some places are naturally better for photographing than others. One of my first landscape photo trips was to a place called Antelope Canyon near Page, Arizona. The desert itself was generally desolate and making a great photo there took some skill. The canyons beneath the desert floor, on the other hand, were so full of interesting details that I could point my camera in any random direction and get an image worth editing and printing. I have often heard this kind of place referred to as a "target rich environment." Large cities can be the same way. I recently took a trip to visit my brother in Chicago; just for fun I quite literally set my DSLR camera to full auto, pointed it in a random direction, pushed the button, and then checked the image. It only needed a small amount of cropping and it was actually a relatively good shot. A location like that, combined with a little work, can yield a really incredible photograph.

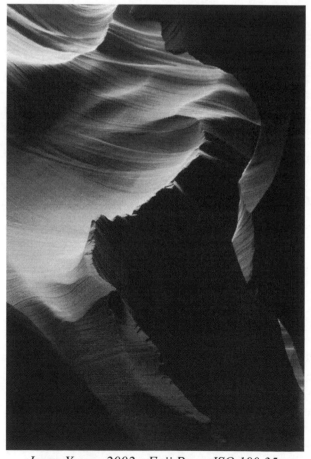

The image to the right is from Antelope Canyon near Page Arizona, It was shot on Fuji Pro-v ISO 100 35mm film on a Canon Elan 7E @ 28mm with an 81a warming filter at f/22 for about 15 seconds.

Since I have mentioned Ansel Adams a few times, I'll use him again. Most of his famous works are of places like Yosemite Valley in California or Arizona's Grand Canyon where beauty is everywhere. A good location will make shooting a landscape much easier, but you may not have to travel far to find one. You may have many great landscapes right near where you live. I live in the American Southwest and it has happened to me more than once where I feel that my current location has nothing to offer. I sometimes find myself thinking that the local landscapes are not really all too exciting because I see them every day; but this line

*Jason Youn - 2002 - Fuji Pro-v ISO 100 35mm film - Canon Elan 7E - 28mm - 81a -f/22 - 15 sec.*

of thought is wrong, and there are some great opportunities for some killer landscape shots right near where I live. Though you may not think so, there are probably some really great opportunities near your house as well. You may be tired of the landscape, or think that the path through the trees is just boring, but in another part of the world, your home looks like a unique far-off land that is most definitely worth photographing.

There is a great photographic organization that illustrates my point perfectly called Through Each Others Eyes, or TEOE (www.teoe.org). Their mission statement is simple: *"Through photography, Through Each Others Eyes™ helps people around the world understand and appreciate cultures different from their own."* They operate much like a high school or college foreign exchange program, only it is for photographers of all ages. They work with countries like China, Japan, Czech Republic, and even Cuba. A photographer from their country comes here for a few weeks and then a photographer from the U.S. goes there for a few weeks. At the end, there is a great gallery exhibit and exchange, and the two cultures come to understand each other better.

I know that was a bit of a tangent but my point with this story is that sometimes there are great photos right under our noses, and they go unnoticed because we become accustomed to our location. An exchange like this is a great way to shake things up and let other people photograph our neighborhoods so that we can see as they do. If a foreigner were to come to where you are, what might they find interesting? Take some time and try to photograph the landscapes around where you live as if you had never seen them before. Location is important but sometimes the best location is the one that's right in your backyard or just around the corner.

**Composition**

For landscapes, although having a target rich environment will make things easier for you, it's not necessary.  Good composition, however, is a must. In some of the composition examples from chapter 5, I showed the same image with the horizon in the middle of the frame and another with the horizon on the bottom third line. Most people would agree that using the rule of thirds for the horizon strengthens an image. Good composition will make or break a landscape. Even though your photo may simply be of a field, without a subject for the viewer to focus on, your image will likely be boring. Find anything that looks interesting and place that right in one of the four intersecting points that are made by the rule of thirds. Also try to have a few leading lines pointing at that subject, and of course try to make sure your image is balanced. If you don't like

the composition, move a bit from side to side or up and down until you get the framing you want. Keep composition in your mind as much as you can. Location may be important but good composition is an absolute must.

### Camera Work

Beyond just location and composition, another must have in landscape photography is good camera work. Exposure, depth of field, shutter speed, and ISO noise all play a part in how your final image will look. While there are times when a small depth of field works for a landscape, the normal goal of a landscape image is to capture the entire landscape, and a small aperture that will render a large depth of field is often times the way to go. Since a small aperture does not let in as much light, your shutter time will be longer, sometimes more than a second. Beyond that you will probably want to shoot at your camera's lowest ISO setting. While a high ISO will let you shoot handheld in low light, it also introduces noise, or grain, into your image. For landscapes, this is normally a bad thing, so keep your ISO low, but the trade off is, of course, longer shutter times. As a general rule, if you are shooting landscape photography you will need to use a good sturdy tripod and an off-camera shutter release button. If you don't have one of those buttons you can also use the timed exposure release option. Either way the goal is to eliminate camera shake. It has happened to me more than once where I have a beautiful photo and there is just a bit a blur caused by a shaky camera. It's frustrating and sad, but we live and learn. <u>Use a tripod.</u>

Once you have taken your image, the next trick that all the pros use is to take another, and then another, but don't just keep making the exact image, bracket for exposure. Your camera may have an auto exposure bracket feature. If you have this, great! You have an easy way to make sure you keep getting shots that are exposed differently. If not you will have to do this manually. Either way the goal is the same -- to give yourself options with your image. You may think that your exposure is correct when you take your photo, and then when you are back at your computer editing, you decide that you actually wanted just one more stop in one direction or the other. If you have been bracketing for exposure, you will have another shot that is identical but a little brighter or darker. When I shoot landscape photos, I normally take 5 shots in rapid succession. I start with two stops under, then one stop under, then proper exposure, then one over, and then finally two stops overexposed. Then I wait a moment for the light to change and do it all over again.

### Landscape Lighting

If you are out shooting landscapes, most of the time your light is changing rapidly and with it, the image that you capture is quite different from one moment to the next. Why does the light change so quickly? Because the next landscape secret of the pros is that a landscape photo is not a picture of the landscape at all. It is an image of an illuminated world. You are simply capturing the light that radiates from the environment around you, and light is at its best at the "golden hour" or right around sunrise and sunset. It is also at this time that light changes very rapidly, so be ready to do all of your photography in a small window of time. Midday is a great time to prep your gear, or to scout a location and perhaps make a test shot or just kick back and have a beer with lunch. The real work with landscape photography almost always takes place at the golden hours of the dawn and dusk of each day.

### Weather

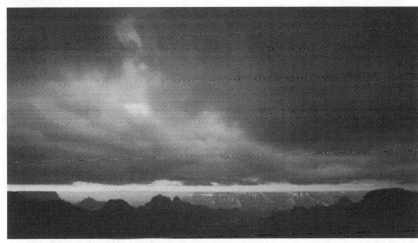

Jason Youn
2007
"Storm at Bright Angel Point"
Canon 5D
15mm
-2EV
ISO 100
f/11
1/40th

We wait for the best light because perfect lighting can transform an otherwise uninteresting landscape into the kind of image you keep in your portfolio or hang on your wall. One of the ways that light is perfected is through modification, and when it comes to the vast landscapes of this world, the only light modifier large enough to work on a Grand Canyon sized scale are clouds and other suspended atmospheric particulates. Massive clouds, thunderstorms, snow, ice, rain, fog, haze, and inclement weather are perhaps the best kept secrets of landscape photography. Hardcore landscape photographers are running right for the middle of the storm when everyone else is heading indoors to take cover. Not only does this weather do interesting things with the light, it also becomes part of the composition and sometimes it becomes the focal point of your image. Unlike the rest of the landscape that changes very slowly, the weather changes with the wind, literally. The image you make during a thunderstorm will be something

fairly unique. The landscape may always be there, but finding that cloud with the same light will be rare. The next time the weather turns bad, grab your camera, your tripod, and a good rain jacket. Go back to that spot that was almost good enough last time. You may find that it is more interesting, has more impact, and in a very obvious way has been perfected by the weather.

### Like the Pros

There is a popular state-run magazine called *Arizona Highways*. Though they have articles about all things Arizona, they are mostly known for their world class landscape photography, and they love the thunderstorms in the open desert. Every issue has some great photography, but there is also a common theme to the images they publish. If you want to get a stunning landscape shot you can easily copy their style in just a few steps. For gear you will need: a camera, a wide-angle lens, a tripod, and a golden sunset with some clouds. Find your location long before it's time to shoot. Scout around. While you scout you don't need your tripod, just handhold your camera look through the viewfinder, and perhaps take some test shots. Find a composition something like this: put something large and epic in the background like a mountain, find something else that relates to the landscape like a tree or a rock or even a beat up old truck. Keep the horizon on or near the top third line. Place an interesting part of the mountain in the top left third intersection point or perhaps just below it. With your smaller object, your tree or truck or whatever you want, place an interesting part of the subject on the bottom right third intersection and have some of it extend out of the frame. Have your camera on a tripod so that you can set your ISO to something low (like 100) and your aperture to something constricted (like f/22). This will get you good grain and image quality and a very large depth of field. It may be best to have the sun just over your right or left shoulder but the most important thing about the sun is the time of day. For your keeper shots you will want to shoot at either the morning or evening golden hour. Remember to bracket your exposure, and perhaps keep reframing to give yourself a few options for composition. For best results, do all of this when it's storming, raining, snowing, or perhaps just after the storm when the effects of the weather are still present. Get ready to take lots of photos and toss most of them in the trash. Your goal is just one or two good images. Follow these tricks and by the end of the day, you will have a photo in the style of *Arizona Highways* magazine and just like that, you have become a bonafide landscape photographer.

This image was taken at night in the Superstition Wilderness of Arizona, at f/8, ISO 200, 1/15th, @ 16mm. This photo is, for the most part, the formulaic landscape style that is described above. It was taken with a wide-angle lens so the mountains in background look farther away than they are. There is something large in the foreground, in this case a saguaro cactus. The rule

of thirds is used for the mountain and the cactus. Of course, there is interesting cloud cover. The one thing that sets this image apart is the way the lighting is happening. Most of the time landscapes are lit by the rising or setting sun. In this case, most of the light comes from cloud-to-cloud lightning. The effect of this lightning is that the light is very soft, and even appears

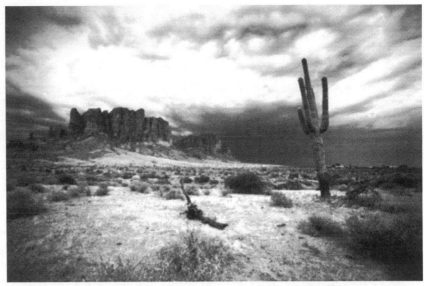

*Jason Youn - 2007- Canon 5D - ISO 200 - 16mm - f/8 - 1/15*

to be coming from many directions at one time, but because the lightning is so far away and never touches the ground, there is no single bolt that is visible, rather the late night clouds look to glow on their own.

After you capture your image, step two is editing, and that can also take a good deal of time. Though this book is not really about editing, I will note that is an important thing to learn. Keep in mind when you edit that it can take lots of time. If you are working slowly, that's just fine. When I don't have deadlines, and I am shooting for my own satisfaction, I don't even start editing for several weeks, sometimes months after I shoot. I like to give myself time to forget what I saw, and what I wanted. This way when I sit down at my computer I have the chance to see the images for what they are, in front of me, rather than what I think they should be in my mind.

Ansel Adams has a famous photo taken in New Mexico at night (*Moonrise*, Hernandez, New Mexico, 1941). There is a highway, a small town, some mountains, and the moon. Though it took him just a few minutes to take the photo, he spent the next few months editing, printing, dodging, burning, and just generally playing with the image in the darkroom before he had a photograph that he felt was worth showing off. Editing, like most things worth doing, takes time. Your landscape images are worth your time investment. They won't look anywhere near their best until you edit and adjust them, however you will do yourself a big favor if you get a good image from your camera before you start editing.

One last note about landscape photos. This is a quick list of things that I usually keep with me when I shoot landscape: 1) Good shoes and appropriate clothing -- I have learned that if I

suffer, my work suffers, so I pack for the wilderness. 2) Water and some snacks -- Still this is all about taking care of myself. 3) Camera gear -- A good camera backpack that will hold everything I need: my camera, and tripod, a wide angle lens, a normal lens, and a long lens (most of the time I use just the wide but I like to keep my options open). I keep extra memory cards, batteries, and a camera plate for the tripod in addition to an off-camera shutter release button and some things to clean my gear in the field. Sometimes I bring a small backpacking stool to sit on. For filters I keep a polarizer and sometimes a UV haze filter. In these days of digital cameras all other filters can be reproduced in post, although a graduated ND filter can still come in handy. Speaking of digital I always shoot landscapes in RAW, not JPG. This yields the best image, highest dynamic range, and the most options when editing. A few other non-camera related things I like to bring are a multi-tool knife, flashlight, GPS to mark my location, some basic first aid stuff, a handkerchief, and a cell phone just in case. These days I also bring a 720 nanometer infrared DSLR. I have a lot of fun with it, and in just a few pages I will talk much more about that unique type of camera. This stuff is my personal list. Once you get there, you'll want to modify this list to fit your needs. The important part is that you keep shooting. You won't like your first images and that's ok. Get ready to shoot more and you will love where your photography takes you.

**Landscape photography recap:**

•Use a tripod, bring an extra camera plate.

•Use the rules of art, balance, thirds, etc.

•Weather will help make things interesting.

•Shoot within 30 minutes of sunrise or sunset.

•Scout your location before you shoot.

•Locations that are common and boring for you, may be new and exciting to someone else.

•Shoot in RAW mode.

•Shoot at a low ISO.

•Bracket for exposure.

•Normally shoot with a small aperture f/11 or higher.

•Wear good footwear and clothing.

•Get a decent camera bag backpack that will also hold your tripod.

•Bring extra camera batteries, memory cards, and a flashlight.

•Bring water and a snack.

•Have fun.

# Shooting at Night

Photography is all about capturing and recording light, yet some of the most stunning photos take place where light is scarce. I think of places like Paris with the Eiffel Tower at night all lit up with strands of white lights. I think of stars streaking across the sky. I am reminded of millions of lights on a skyline that reflect off the still waters of a bay or the neon glow of the Las Vegas strip. Night photography comes with both challenges and rewards. The images are stunning because they are beautiful and they are beautiful because they are all about something that can be difficult to find at night: lots of light.

Step one in night photography is to bring a tripod. Much of night photography is, in reality, just landscape photography. Sometimes it takes place in the city so we call it a cityscape, but the rules, techniques, and skill sets are very similar. Shoot on a tripod, use good composition and camera work, make sure the lighting is interesting, and get creative.

### City or landscapes

With normal landscape photos, the sun is your light; when you shoot at night your light source could be just about anything except for the sun, and this can present a few challenges. For one, your exposure meter may be a bit off. Your light meter works by looking for reflected light and middle grey. Oftentimes night photography has a source of light as part of the composition, and your light meter can be fooled. To correct for this you may need to overexpose your image a few stops or more. Let's say you are shooting a night scene and your settings are f/8 ISO100 and 1/4 of a second. You look at your preview in your camera and the image is just too dark, yet your exposure bias is maxed out. If you need to shoot with your exposure bias 4 stops higher than normal, you now have a problem. Most cameras only have a bias good to two stops, so what do you do? Switch to manual. Set your camera the way you want and just keep adding time, or adjusting the aperture until the image looks right. Perhaps your new time is 1 second that would add two stops of light to where you were before, and could be just what you need. Shooting at night does not necessarily mean that you will have to add 4 stops more than what your meter says it needs. Usually your light meter is spot-on, or at least close, even under some fairly strange circumstances, but nighttime is definitely a situation when your camera's metering can be way off, and nighttime is also a time when long exposures are common. If you are working on a tripod, you should have no problems with long exposures.

Shooting at night in the city also means you will most likely be working with mixed color temperatures of light. Try playing with different white balance settings until you get the one that

you want. Or if you just want to fire and forget about white balance at night I recommend two things. You can either set your camera to auto white balance and this will work well, or you can work with color as if you were shooting film. Almost all camera film is set to "daylight" balanced. If you are in a tricky mixed-light situation, choosing the preset for daylight will often work fairly well for you.

Above all, shoot for good composition.

### Night Shot Mode

If you want to shoot handheld shots of people and there is not much light, you can use a preset on your camera, called "Night Shot" or "Night Scene" mode. Most DSLRs, Crossovers and Point and Shoot cameras have this built in, but you can also get the same effect using manual settings. For "Night Shot" your camera will sort of put one foot in each river. It will take a long exposure that would normally blur; it does this so that the background will not look very underexposed; it may have some camera shake due to the long exposure, but that's ok. Then at the end of the shutter being open it uses the flash to fill the foreground. Normally your foreground is people. The flash duration is short, something like 1/12,000th of a second. So the part of the image that flash illuminates is crisp. This is great for parties or other nighttime shots where you want a good shot of people but you don't want the background to be totally dark.

If your camera does not have this mode, simply put your camera in manual and get the exposure so that the background is about 1 stop underexposed, perhaps 1/10th of second. Then set the flash so that it properly exposes your foreground subjects, make a test image and then adjust the settings until it looks right, then create the real image. Once your settings are right you should be good for several subsequent shots.

### Shooting at night recap:
•Always use a tripod.
•Use off-camera shutter release.
•A long exposure is critical.
•Good composition is just as critical.
•Think landscape photography.
•Think about many lights & mixed light.
•Bracket your exposure.
•Sometimes shoot in manual.
•Night shot mode does not need a tripod.

**Very Long Exposures >30 seconds**

Every time you double your shutter time, you add one stop of light, until you reach something called reciprocity failure. In the days of film, this was an issue that people found with very long exposures, and the phenomena exists today; however, today the digital benefit of immediate proofing makes reciprocity failure much easier to deal with. You may encounter this problem with photos that are exposed for more than 30 seconds. For those very long shutter times, the rule of reciprocity from chapter 3, where you keep the shutter open for twice as long to expose the image one more stop, stops working. At this point you just kind of have to guess. One thing is for sure; one more stop of exposure will take longer in terms of shutter time than the reciprocity rules will indicate, but how much longer becomes hard to predict. Luckily for us we can review the photos instantly on the back of our camera; in the days of film that was not an option. To take a long photo you will also need an off camera shutter release button with a shutter lock feature so that you can lock the shutter open. You will have to set your camera to the "Bulb" setting, often denoted as the letter "B" in your mode selection dial or menu. In this setting the shutter will stay open for as long as the shutter release button is depressed. The off-camera button with lock will allow you to lock the shutter open for as long as you like, then close it later.

Try this some time: Put your camera on a tripod and get your aperture small and ISO low so that you can get a slow shutter speed. This will be easier in very low light situations. Since you are trying for a shot longer than 30 seconds you will likely need to use bulb mode with a locking off camera shutter release button. The colors that you record may surprise you. The different spectrums of light can do some strange things in a very long exposure.

You will also run into another problem. When your DSLR is making an image, electricity is passing through the image sensor and over time that current introduces digital noise. Even though your ISO is 100 it may produce an image that has noise and grain like you shot it at 400 or even higher. This is normal and is just a byproduct of shooting with very long exposures on a digital camera. Much of the digital noise is actually caused by a build up of heat resulting from the electricity in the sensor. (If you shoot with film you will not have more noise with longer exposures.) That same type of noise will also be introduced if you take many photos in rapid succession; the later photos in the series will have slightly more noise than the first ones. If you find that you enjoy shooting long exposures often, you might want to invest in something to help with thermal noise. One such product is a DSLR camera cooler. It is basically just a box with

some fans and a heat-sync to keep air moving over the camera and keep the setup a few degrees cooler. There are a few on the market and they also appear to be easy to rig up DIY style. The end result is a fairly substantial reduction of digital thermal noise for very long exposures. For the most part this is only really popular for people who like to photograph stars. It is especially popular for people who like to attach a camera to a telescope, effectively making that telescope into a gigantic camera lens. Digital noise can really mess with a star photo as it can become difficult to distinguish an actual star from the image noise. What a great time for a segue to photographing stars at night.

**Very long exposure recap:**

•Reciprocity failure will make calculating exposure times difficult.

•Use a sturdy tripod.

•Use an off-camera shutter release with shutter lock.

•You might see unusual colorations of light.

•You might see extra digital noise (digital only, not a factor in film).

•If you have IS or VR turn that off. (This is critical: <u>Turn off the image stabilizer.</u>)

## Photographing the Stars

There is something captivating about looking up at the night sky. For as long as there has been culture, fascination with the heavens has been part of humanity. If you live in a city like I do, then you probably forget how beautiful the night sky can be. When I get out from under the iron dome of civic light pollution that turns the night sky into a pale dull orange glow and I look up at the evening sky, I am simply struck by its beauty. For a time all I can do is stand there and watch...then I go for my camera. But photographing the sky is not like photographing anything else. Like so many other types of photography, astral work comes with its own challenges. For one, autofocus rarely works. Auto white balance can be a bit off as well, and auto exposure is worthless. It may not look like it but stars move rather fast, even a 20 second exposure can show the movement of a star when examined closely, and because they are just tiny points of light, any camera shake at all will cause them to blur. If you want to capture those long star trails where it looks like each star has drawn is own arch across the sky, get ready to have your shutter speed at 10 minutes or more. Another challenge is light pollution, cities can have so much light they overpower the stars, so you may want to get out of town for this. Not all light pollution is manmade. If you want to shoot stars, you will probably want to go out on a moonless or near moonless night.

Just like in any other type of photography where the shutter is open for a long time, a very sturdy tripod is an absolute must-have in order to avoid camera shake. Unlike most other long exposures, star photos have millions of pinpoints of light. As a result, they show off camera shake in a very obvious way--so much so that you will want to use a feature on your camera called *mirror lockup*. When you take a photograph with your DSLR, your camera first moves a mirror up and out of the way of the shutter, then the shutter opens, your camera makes the image, the shutter closes, and the mirror comes back down. This mirror moves very fast and, though it is lightweight, it still introduces some vibrations that take a quarter second or so to settle down. If the camera were to operate normally, those vibrations would show up in a photograph of stars. The mirror lockup function allows the mirror to move up when you first press the shutter release button. A moment later, the shutter opens, eliminating the problem of camera shake from the mirror. You will want to consult your camera owner's manual to find out exactly how to enable and operate this on your camera. If you are using a mirrorless camera, mirror lockup is not necessary and won't even be an option.

Your hand on the camera operating the buttons will also introduce camera shake, so an off-camera shutter release button is a must. Not only do you need this for camera shake, but in most cameras you also need an off camera button to shoot for longer than 30 seconds. Another common way camera shake is introduced is with the image stabilization that is built into your camera or lens. That stabilizer is great for hand-held work, but when your camera is on a tripod this feature can actually cause camera shake, so make sure that image stabilization is turned off as well.

Now that you have your gear and your camera in order, here is how you capture a great shot of the stars. With your camera on a tripod, mirror lockup set, IS off, and the off-camera shutter release button connected, compose your image. I like to place a bit of land in the image for a sense of scale; this also helps keep the stars framed. For this type of image, shooting in RAW mode is a must as it will make editing your images much easier. For white balance, if you get a good mid-range K setting (3500 to 5500), you can then play with the white balance when you edit the images later on your computer to get the colors you want. I like to shoot stars with my white balance set to either daylight or tungsten. If there is a city nearby, tungsten is better since most of the light pollution in your image will be fairly orange. For ISO, low is better but low will increase the time the shutter is open. I prefer to shoot at ISO 100, but 200 or even 400 is probably fine depending on the low light quality of your camera.

OK, you have your image resolution, white balance, and ISO set; next you will need to decide how long you want the exposure to be. The longer the exposure, the more the stars will show movement. A handy rule is that for a normal lens, less than 15 seconds will show a pinpoint of light and greater will start to show streaking from the movement of the stars. The longer the shutter is open the longer the star streaks, or star trails will be. For a wide angle lens you can change that to 30 seconds, but for a long lens it will be substantially shorter.

You can shoot with your aperture wide open and I often do because I want a shorter exposure to capture pinpoints of starlight, Or you can stop it down for a longer exposure. Your lens will be sharper and focus will be easier around f/8 but the exposure will be longer. Perhaps that is what you want. This is a trade off and a decision for you to make. Set your focus to manual, because autofocus won't work. For an easy way to focus, look through the view finder and get the stars as in-focus as possible. For a more accurate way to focus, use the hyper focal distance and set your lens accordingly or you can also find where your lens focuses to infinity, and dial it back just a bit from there.

Now your camera is on a tripod, settings are set, focus is set, and your image composed. Time for a test shot. The last thing to do is to cover your eye cup. In an SLR small amounts of light can actually enter your camera from the viewfinder. This is normally not a problem but for a very long exposure it can make a difference. If your camera is like mine there is a small rubber thing on the neck strap that fits over the viewfinder to keep light out. Remove your eyecup and replace it with that cover. I have found these covers to be hard to use and prefer to use some gaffer's tape instead. I just cover the eyecup completely for the shot and take it off when I am done.

Since long exposures have reciprocity failure, one more stop of light won't always mean adding a stop of time or aperture. You will have to do some guessing and checking and lots of exposure bracketing. For a good starting point you may try ISO 100, f/5.6 for 5 minutes and see how that looks. You should have some nice star trails with that exposure time. Keep playing with settings and times and keep bracketing. More photos in the field mean more options when it comes time to edit.

If you really get into photographing stars you can have your camera modified to filter out light pollution. These modified cameras are called H-Alpha cameras. They don't let in much of the visible light but they do let in a narrow spectrum of Alpha light created by the hydrogen fusion reaction in stars. The result of using this camera is that the lights from the nearby city that reflect off of the dust and pollution in the air don't wash out the sky with an orange glow that would otherwise appear in a photograph and can be seen in the sample image below.

This was taken on a tripod around 3 hours after sunset. The orange glow is from the lights of Phoenix located about 90 miles away. This was taken with a Canon 5D, ISO 250, f/2.8, 16mm, 30 seconds. The stars are just starting to streak but not much and appear in many colors from blue to orange. The city lights glow a fiery orange, the mountains are silhouetted against the night sky, and there is no moon.

If you are interested in lunar

*Canon 5D, ISO 250, f/2.8, 16mm, 30 seconds.*

photography, you will set your camera up much like you would for the stars, but a full moon is much brighter than a moonless star-filled sky. A common camera setting for a full moon is about ISO 100, f/11 and 1/125. Because you will want to use a very long lens for the moon, you will still want a tripod. Zoom in as far as your equipment will allow. Depending on where you are in the world, and the amount of atmosphere you have to deal with, these exposure numbers will change a bit.

**To recap photographing stars:**

•Use a tripod.

•Use mirror lockup.

•Turn IS (Image Stabilization) off.

•Shoot in RAW.

•Use an off-camera shutter release button.

•Incorporate the ground or trees.

•Shoot on a moonless or nearly moonless night.

•Get out of town.

•Put your ISO as low as you can manage (100 ISO is good).

•Time < 15 seconds = pinpoints

•Time > 15 seconds = streaks

•Aperture f/8 to f/11 = sharpest image vs. a wide open aperture = faster shutter speed.

•Block your viewfinder.

•Bracket your exposure.

•Expect an increase in digital noise.

•Consider an H-Alpha spectrum camera (serious star people only).

## Lightning

Photographing at night comes with challenges, when your subject can appear and then disappear with a blink of an eye and without warning, the challenges of nighttime lowlight shooting get a bit more difficult. This is the nature of photographing lightning and though it's hard to know exactly when and where lightning will strike, it is not impossible to get a general idea of a time and place lightning is more likely to occur. Like gambling, getting a good photograph of lightning involves increasing your odds. Step one, go out when lightning is more likely, and point your camera in the direction of the lightning. The good news about photographing lightning is that it is very bright and the rest of the night is very dim. As a result you can think of lightning as your camera's flash; only you don't know exactly when it will fire.

When you use your camera's flash your shutter opens for 1/250th of a second or less, the flash fires for around 1/20,000th of a second and in that instant your camera gets all of the light it needs. The rest of the time your shutter is just sitting open and the light it collects is not much of a contribution to the image. Lightning is the same way, only exposure times are much longer. Like setting a trap and waiting for a mouse, you open the shutter of your camera and wait.

Just like with shooting a night landscape of a city, set your camera on a tripod and get the settings right to expose your environment. You may want to set your camera at about one stop underexposed as the lightning can add some light. You will need to keep your shutter open long enough for lightning to strike. For example, if you can make your image in 2 seconds at f/5.6, change your settings to f/16 and 15 seconds, 3 stops longer. Make your image. In that 15 second window you are hoping that lightning will strike. As soon as the shutter closes make another image. Keep doing this. Over the course of your shooting session your shutter will be open much more than it will be closed and you will capture several strikes. Sometimes you will get a few bolts all in one image.

Another bit of info with lightning is that you should consider what the bolt may look like when it is captured in your camera and compose your image accordingly. Keep in mind the streaks of light and electricity are a part of your composition. Because lightning can strike unpredictably, your goal with this process is to increase your chances of getting a lucky shot. So compose each image well and hope that lightning strikes; keep the good ones and delete the rest.

### Lightning Recap:
•Use a tripod & an off-camera shutter release button.
•Shoot in RAW.
•Use good composition that incorporates your expected lightning.
•Choose a low ISO.
•Prepare for a long exposure (15 seconds or more)
•Take lots of images.
•Every shot is a gamble.

**Fireworks**

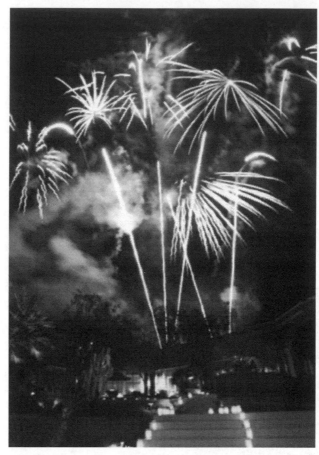

Jason Youn
2009
Canon 5D
15mm
ISO 400
f/5
2.0 Sec

For something a tad bit less challenging than lightning, try photographing fireworks. For this you will operate much like you were photographing lightning, but you have the advantage of knowing exactly when and where your fireworks will strike. The one difference with fireworks is that instead of a bright bolt they are more like stars in the way that they incorporate bright moving spots, so shutter speed plays a role. A fast shutter will freeze the bright burning colorful embers, and a slow shutter speed will provide some nice soft streaks of light. Keep bracketing, and try out different shutter speeds to see what amount of streaking you like for your image.

Just like in many night shots, autofocus won't work, so be careful to set your focus properly.

Since fireworks are at night and in full of color you will be working with mixed light so getting a perfect white balance is more of a personal preference than a science, and you will most likely have to play with the settings when you edit your photos. When you shoot, set your camera to a white balance preset so that all of your photos will have the same white point. I like

to use daylight, but you can use any of them. I would stay away from the florescent preset for fireworks since that will give everything a magenta cast.

**Fireworks recap:**

•Use a tripod.

•Shoot in RAW.

•Set W/B to Daylight.

•Use manual focus.

•Use good composition that incorporates your expected fireworks.

•Use a low ISO

•Long exposure = streaks of firework light

•Short exposure = pinpoints of firework light

•Take lots of images.

•Bracket your shutter speeds.

•Bracket your exposure.

•Every shot is a gamble.

# Black & White Photography

Perhaps it is not fair to address black and white photography with just a sub-chapter, but here goes. Black and white photography is all about contrast and composition. Differences between light and dark, and all the shades of grey in between are the sum total of the image. The placement of these tones in the image is your composition. The idea that orange is brighter than its blue complement and thus has more weight, or attracts more attention, no longer applies. A red object and a grey object can be equals in black and white if their tonal value is the same. Since color is no longer a factor, contrast is key. When you are shooting and editing for your black and white image, make sure that your photo has at least some pure white, and some total black. After that the mid tones are up to you. A full tonal range is good, but the black and white are imperative.

Composition is more important than ever. Color adds so much to an image; it complicates things and can become the primary subject with ease. Remove that factor and now things like balance and the rule of thirds or leading lines become even more valuable. Because most people see in color, a black and white image forces the viewer to see the world in a new way. By controlling the composition, you control their gaze.

Because the viewer will automatically notice the bright spots, or white points in the image, these will likely become the focal points, so use them to your advantage.

In this world of digital, black and white photography has taken on a new twist. The first photographs were all black and white, color would not come along until the early pioneering photographers were dead and gone, and until recently we have had to choose: black and white or color film. Now we have a new option: decisions after the fact. We no longer have to decide when we shoot. One of the great advantages to digital imagery is that these kinds of choices can be made back at home on your computer, and converting to black and white can save an image that has technical problems with color, mixed light, or contrast. There are plenty of times, especially at events where mixed lighting does some strange things to photographs, or digital color noise causes undesirable effects, that converting to black and white fixes these problems outright.

Now, you can't just convert a photo to black and white and call it art; if you try that you will be disappointed. But for those photos where color issues are killing the image, converting to B&W may just save the shot. After you convert, play with brightness, contrast, and all those

other little settings to get the image to be the best black and white image it can be. Make sure you have blacks, whites, and mid-tones. Make sure your composition is right (you may want to crop your image to improve the composition). By the end of the edit, converting to black and white may just save that shot.

Black and white photography is an art fully unto itself. If you get into it, I would encourage you to ditch your digital camera for a while, and pick up a film camera, either 35mm or medium format. Learn to work in a dark room with contrast filters. Not only will you have a blast but I guarantee you that your other photographic skills will improve as well. I love working in a darkroom, but the chemicals can be a real challenge, and the cost can skyrocket fast. My advice for darkroom work is just two things: One, don't go it alone. Take a class at a local community college. Taxpayers offset the cost of these neighborhood learning centers, you already pay taxes, so use them. Beyond that, your local CC probably has a great darkroom that a staff member cleans and maintains for you, so all you have to worry about is the fun part. The classes usually have peer review on the photos that each student creates. This kind of review will also help you along your way. Simply put, community colleges are a great way to learn how to take black and white film photos. The next thing I can say about black and white film dark room work is this: Do it ASAP. It's fun and rewarding and will make you a better photographer.

*Jason Youn - 2009 - Canon 5D    ISO 100 - 70mm - f/2.8 - 1/100*

**Black & White Photography Recap**

•It's all about contrast.

•Look for pure blacks and pure whites.

•Composition is a must.

•Learn to shoot film.

•Learn to print film in a dark room.

# Rugged Point & Shoot Cameras

I know this book is about learning how to gain complete control over your camera, the composition, the lighting, and so on. Sometimes, however, it's nice to sacrifice some control and some image quality in the name of portability and ease. For that, I love my point and shoot camera. I own several digital and film cameras. They all work well and all fill different niches in my photographic arsenal. So when it came time to buy a point and shoot camera I asked myself, what do I need in a camera that I don't already have, and what do I want this new camera to do.

My very first considerations for a point and shoot were that it had to be small, light, easy to use, and waterproof. For all of the wonders of my cameras none of them could go under water. So that was a must. Next I wanted a camera that had great image quality, and the camera should power on quickly so that no shot gets away. With those points in mind I started my hunt for the perfect small, rugged, high-quality point and shoot camera. What I discovered was a bit sad but not entirely unexpected. No one makes what I want. When it comes to portable point and shoots, the name of the game is sacrifice. There is no camera that is everything I want and so if you are like me, that means when you buy one, you have to prioritize your needs. It also means that shooting on a point and shoot camera can sometimes be a bit of a challenge.

The first thing to remember with a point and shoot is that the rules of composition go unchanged. Keep using the rule of thirds, balance, framing, etc. Next keep in mind that your images will be good but not as good as a DSLR. I have not found a point and shoot that is both waterproof and shoots in RAW, but the size, of the camera, the ability to go snorkeling and swimming with the camera, and ease of use make up for the lack of control and lower image quality. If there were a higher end waterproof rugged point and shoot, I would buy it a heartbeat. For the limited control that you do have on your point and shoot, there are still some things that you can do to make your image better.

Most point and shoot cameras have the ability to control what kind of flash decisions the camera will make. You can normally force the flash to fire and use that for a fill-flash, or you can force the camera to have no flash at all. For using your camera's on-camera flash, the rules of flash photography are similar but it is harder to gain complete control. You will also probably have some control over auto exposure bias; this will come in handy when someone is backlit, or if you are shooting at night. Most point and shoots also have controls that will give you limited access to adjusting the shutter speed and aperture. The real difference with point and shoot cameras is that most of the time these controls are buried inside of the camera menu system so quick access is not an option.

Alternatively you can give more control to your camera's computer and simply select a scenic mode for your camera. My little camera has about 15 modes. Many of them are actually fairly redundant settings so I only use about 4 modes. With this approach I simply select my situation and trust the computer to make good choices for me. If I am shooting macro, I place the camera in macro mode, the same goes for portrait, landscape, night shots, sports, or underwater. When I am shooting with a DSLR I normally hate giving over that much control to my camera, but for point and shoot photography I have found that this really is the way to go. While I would not normally do any pro work with my little rugged Nikon, I love it for hiking, hanging by the pool, snorkeling, using at parties, keeping in my pocket, or just having around. As a bonus, my point and shoot also takes HD videos. If this is something you will use then keep that in your consideration when you buy. I didn't really care about the video feature when I was shopping, but now that I have it, I have come to love it.

If you use a point and shoot, play with every mode and setting you can find. If you mess something up, go to the part of the camera's menu where there is a system restore, or settings reset option, and take all the settings back to the factory default, then start playing with the settings again until you have them the way you like.

The only accessories that I can think of to have with a small point and shoot are a tiny bag, perhaps a spare memory card and battery and most importantly, a small cheap compact tripod. When I have talked about tripods before I have noted that you will have to spend at least $100 to get a worth while tripod. In this case you can spend far less. The one I keep for my point and shoot cost me about $10, it only sits about 10 inches high, it can attach to a tree or post, it weighs almost nothing, and it's durable.

One of the great things about my point and shoot is that I can hand it to a non-photographer and I don't get the ubiquitous "what button do I press" question. It's tough, small, waterproof, and relatively cheap. Because of its size and weight, it can go anywhere and be mounted to anything -- like a helmet or airplane wing. When all is said and done, it actually takes some really good photos that are definitely worth printing.

**Point & Shoot recap:**
•It's easy to use.
•Don't forget the rules of art
•Find one that fills a niche that you don't already have (like waterproof).
•Decide if video is a need.
•Use the program modes (macro, landscape, portrait etc.).
•Buy a cheap small compact tripod and perhaps a helmet mount (for you skateboarders and bikers).
•Play with every setting.

*Chapter 8*

# Less Common Tips & Tricks

## Bokeh & Lens Flair

Even after all the fancy gear, computerized sensors, waterproof housings, giant light kits, and 40 inch prints, photography is still about just one thing, capturing light. When we shoot, we use a lens to focus light onto a sensor, or film. When light is reflected off of a subject like a person or mountain and is focused and collected, your lens works just as it should, but when the source of the light is in the frame of the photograph, you can capture some elements that are actually artifacts of the lens itself and are not anything that exists out there in the real world. For quite a long time in photography and cinematography these were considered mistakes, and unacceptable, until one day a documentary film director in the Amazon captured a lens flair on film and decided that he liked it. It went to print, and overnight, lens flair became not only ok, but cool.

Lens flair happens when a bright spot of light appears as a projection on an internal lens element. That projection then becomes part of the image. You have probably seen this in movies as a camera pans down across a desert, or shoots through the leaves of a tree. If you are trying to perfectly capture the world as our eye sees it, lens flair would be as tacky as drops of rain sticking to a camera lens, but if you embrace and incorporate lens flair, you can end up with a stunning image.

To make lens flair you will normally have a light source in your image shining toward you. You will notice little circles of color and streaks of light cast across the scene. Play around with it and make it part of your composition.

Jason Youn    2011    "Spring Creek Ranch"
Canon 5D - 16mm - (-1EV) - ISO 50 - f/22 - 1/10th

### Bokeh

Bokeh, like lens flair, is an artifact of the lens itself. Unlike lens flair, it has more to do with the aperture shaping a bright pinpoint of light in the image. Bokeh, pronounced BO-KEH, is from the Japanese word "boke" (暈け/ボケ) meaning fuzzy. This means the background is out of focus and there are points of light or highlights in the background that show up as soft fuzzy points of light. These pinpoints of light will take on the shape of the aperture, so if a lens has 8 blades to its aperture, the bokeh will be an 8 sided

polyhedron. If the aperture is custom made for the bokeh effect you can really have any shape including hearts, peace signs, numbers, stars, you name it you can have it.

Below is a photo taken with a perfectly round aperture. The bokeh happens to the left side of the frame and in a few pinpoints on the girl's dress. The more out of focus the Christmas lights are, the more pronounced the bokeh effect is.

The next image also shows off the bokeh effect. In this case the aperture has been custom cut in the shape of a musical note and the entire image is out of focus. In real life each dot of light is actually a single colorful Christmas light pinpoint.

# Special Lenses

If you want to get some really interesting and challenging shots there are a myriad of special application lenses on the market for you to blow tons of money on. While there are probably more than I can name, these next ones are fairly common and fun to use.

**Tilt Shift**

One common special lens is called a tilt shift lens. These are made by most lens manufacturers including Canon, Nikon, Sigma, and others. The idea behind these is simple. Within a lens are several different lenses called elements. If you shift some of the elements up or down you can change the distortion of the lens to compensate for apparent converging lines resulting from a specific view angle. Here is an example. If you are taking a photo of a tall building and you are standing near the bottom, the top of that building will look smaller than the bottom. With a tilt shift lens you can change the relationship of some of the internal lenses to make the building look to be the same size from top to bottom in the photograph. For this reason Tilt Shift lenses or TS lenses are often used for architectural photography.

**Selective Focus Lenses.**

If instead of shifting some of the elements of the lens, you instead shift all of the elements you can actually create a focal plane that is not parallel to the camera. These lenses were popularized by a small U.S. company that has quickly gained market ground called Lensbaby. They originally started with just one lens and a few interchangeable drop-in optics that allowed for a variety of different options like changing the quality of the optical glass so that you could choose cheap optical plastic, or medium to high quality glass, each creating a different special effect, but the real power was the ability to have part of the image in focus while keeping another part out of focus. They have now added more lenses to their lineup, so many I can't go through them all here, but they include soft focus lenses, oddly shaped aperture lenses, fish eye, zone plate, macro, plastic, and single glass. If you get good at using your DLSR in full manual mode and want to try something a little different these things can be a lot of fun. Because of their simplicity, however, they are manual focus only and will not talk to your camera's computer. If you are creating images for someone else, this can be a nice way to give them something that they have never seen before because they are still rare enough that most non-photographers have never heard of them but because they are fairly popular among artsy photographers, you

Jason Youn   2009   "Red Sand Maui"
Canon 40D - 50mm - Lensbaby, Plastic Optic, Composer Pro
ISO 200 - f/5.6 - 1/1600th

probably won't create anything that has not been done before, although you will have fun. Sometimes that's all that matters.

The image below is of a red sand beach in Maui with a Lensbaby using a single glass optic on a Canon 40D, ISO 200, f/8 1/4000. The lens was tilted so that just a small portion of the photo is in focus. There is almost no post-production on this image.

### Fisheye

Have you ever seen a very wide-angle shot where the entire world seems to bend and distort to an extreme extent, sometimes taking in 180 degrees of view? This is a fisheye lens, so named because someone once thought that this must be how a fish sees our world, though I doubt an actual interview with a fish took place. These lenses produce a dramatic and unreal look, and can be lots of fun. They distort lines so that they bend and make a distance seem much greater. Because they do accentuate distances, they are commonly used for capturing extreme sports and jumps with skateboarders, snowboarders, mountain bikers, but they also have such a strange look to them that they are used for all sorts of artistic applications. Since they distort the world to such a great extreme, a cheap lens is normally just as good as a high end one, and because focus and depth of field are not only a function of aperture but focal length and these lenses tend to be very short, sometimes 8mm or less, tack sharp focus is very easy to attain.

### Pinhole Camera

Most cameras use optical glass to focus light onto the back of the camera where a light sensitive material captures the image. Pinhole cameras work slightly differently. As the name suggests, these cameras have no lens at all; rather they have a small hole that the light passes through. Basically a pinhole camera is just an aperture with no lens. The light passes through the hole and is projected onto the image sensor. The result is a fairly surreal image that has a soft ethereal quality. The old Kodak Brownie box cameras from the early 20th century all worked this way. The only reason for the glass in the camera was to keep dust out.

This was taken with a pinhole camera lens on a Canon 5D. The lens works just like the old Kodak Brownie camera. There is a tiny hole and a small glass sheet to keep the dust out, and that's about it. This one happens to be f/144 so it can take a long time to make an image, hence the smooth soft water in the creek.

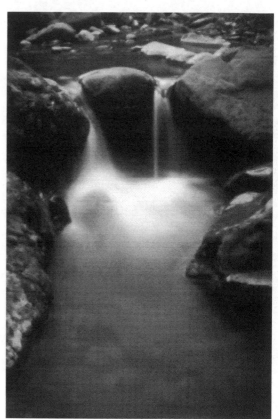

Jason Youn  2011  "Pinhole Cascade"
Canon 5D - Pinhole - ISO 50 - f/144 - 20sec

You don't have to go out and buy something new to play around with pinhole photography. The advantage to buying a pinhole lens is that it is easy to focus the image. If however you are DIY inclined you can make one yourself and can still get some really cool shots.

Try this. Take an extra body cap. This is the plastic disk that comes with your camera to protect it when there is no lens attached. You will need to make a small hole (very small) in the center of the body cap. There are a few ways to do this. I like this method.

Use 1/4 inch drill bit to simply drill a hole in the very center of your body cap. Remember, you are essentially making an aperture, so the smaller the hole the sharper your focus. To make that hole smaller than any drill bit can get it, you will next take a small strip of metal cut from a soda can and puncture a very small hole in it with a push pin or sewing needle. Make this hole as small as you possibly can. Attach the strip of metal to the outside of your body cap with some

light-proof tape, duct tape works but gaffers tape is what you want. Then attach it to the outside (not the inside of the cap) so that if it falls off it does not harm the internal workings of your DSLR. Attach this modified body cap to your camera. If your pinhole is done right, you will be somewhere around f/288. Now you are ready to shoot. The exposure will be long so get ready to use a tripod, but the good news is that auto exposure will work on many DSLR cameras. Just set your camera to aperture priority and let the shutter do the work.

Does this have much of a real world application? Perhaps no, but you can make some cool art with it, and it's kind of fun to play with new things. If you want to really have some fun with pinhole photography, there are tons of DIY pinhole film camera ideas online. I even ran across one that used a roll of 35mm film, the box it came in, some duct tape, and that was it.

### Special Lens Recap

•Tilt shift, often used in architectural work, corrects for distortion due to perspective and distance

•Selective focus, like the Lensbaby brand, modifies the angle of the focal plane & changes what is in focus.

•Fisheye lenses drastically exaggerate aspherical distortion -- very wide angle.

•Pinhole cameras do not use optical glass to bend and focus light -- simply an aperture.

# Cheap substitutes for expensive pro gear - (DIY)

Shooting like a pro can cost a fortune, but the reality is that most of the expensive pro gear out there can be built on the cheap DIY (Do It Yourself) style and the resulting photographs are so good that only the most trained eyes will be able to know the difference.

The pro gear will be built to better specs, it will perform just a little better and it will last longer, but if you are in a pinch or on a budget you can build most things from scratch. Of course a high-end camera body or lens would be quite a challenge to build in your basement but you can certainly build lights, light modifiers, backdrops, props, and mounts on your own, and for pennies on the dollar.

I had to learn some of these tricks when I was in film school. I was a "starving student" and had to come up with money for paper, chemicals, and film, which is expensive. Each 100 foot roll of black and white film cost about 40 bucks and only shot for 3 minutes. On top of that I then had to pay for developing. So, needless to say, finding cheap ways to do all the other stuff was a must.

When it comes to photo gear there are only a few categories. What will make the image, make the light, modify the light, and what will be the background. Although you can DIY your own camera and lenses, aside from making a pinhole lens for your SLR, this is a bit hard to do. Making your own lights, on the other hand, is a great place where you can save money with ease!

### Cameras

Ok, there are several DIY cameras out there, some are simple kits you can buy, and others are not so simple to make but it can be done, especially if you use film. Since it's more of a specialty, and since this section is about saving money on your photography projects and not adding to the cost, I'll skip over the DIY camera part. But if you want to try your hand, this web page has some good starting points for building some pinhole cameras at home http://www.diyphotography.net/23-pinhole-cameras-that-you-can-build-at-home.

## Lights

The best photography lights out there will cost you $10,000 or more for a setup, but you can get some really great pro gear for about $1,500 or so, and you can get some stuff that looks like pro gear but is really just junk for a few hundred bucks, or .... you can also go to the local hardware store and make some lights that will work fairly well. You will probably not be able to make homemade flashes or strobes (if you do have that kind of electrical skill, you probably don't need this chapter) but you can make some great continuous lights that will work well on the cheap. Lighting and lighting modifiers are probably where DIY can save you the most cash.

The cheapest way to get some lights for a small amount of cash is with some clam-on **scoop lights** and a high wattage bulb. You can get the lights for about $8 each and the bulbs will range in price. I would recommend getting all the same type of bulb so that the color of the light is constant. These little work lamps can clamp onto just about anything. I have used everything from a mic stand, to a step ladder, to a buddy with a free hand to mount these lights. With just a few of them you can light up a set well enough to make a good photograph or movie. If you need a brighter light than you can get out of a screw-in-base bulb for a scoop lamp, a set of standard 500 watt **halogen work lights** work great, and you can get those complete with a light stand for $40 if you shop around. The light that both scoop lights and work lights create will be a bit direct and harsh, If that's the look you want, great. If not, you may want to soften this light up, and there a few ways to do that.

The cheapest way to soften up some harsh light is to simply **bounce** it off of a wall or white sheet of cardboard. The goal here is to make the light source bigger. A large wall is bigger than a small lightbulb so the reflected light is softer. So you bounce the first and brightest light off of some white poster board, perhaps make another light a bit more direct, add a hair light and then, just like that you have a 3 light set up with a simple light modifier for under $50. The best part is you may already own some of this stuff.

For more light reflection than just a poster board, try using a **reflective sun shade**. These work well for reflectors that can be used in the sun or studio, they are cheap, and if you get the popup twist to fold style, not only do they travel very well but they are also very close in design to the pro gear. Look for one with silver on one side and black on the other. The silver side will be a reflector, the black side will be a "flag" or an object meant to block out some light. You can mount these reflectors/flags to a stand or better yet, have an assistant hold this out on a bright day to reflect sunlight back into your subject for a fill light.

Another great light modifier, beyond just the white poster-board reflector, is a home made **soft box**. For this you will want a large section of translucent fabric for plastic sheeting. A painter's drop cloth works well. Get a few scoop lights for added brightness and point them right at your subject. Now take the large strip of white translucent plastic and place it between the lights and your subject, the light that you get will be much softer and more even than a bare bulb would be. You can either have two people hold this plastic up while you shoot, or you can build a frame for it from scrap wood or PVC pipe, now you have a DIY soft box for under $20.

There is a neat light modifier called a **globe**. It's basically a translucent ball that goes over a flash head to make the light soft. It not only directs some light to your subject but it also bounces light around the room. You can make one of these out of an old milk jug. Just cut off the top of the jug so that the lamp can fit inside, and you're set. Make sure you don't melt the milk jug; some lights can get very hot. A good light that does not get as hot as an incandescent is a CFL. Since you are working with plastic you may want one of those for this quick project.

When it comes to light, keep in mind: a bigger light source produces softer light, and a smaller light results in harder light. One is not better than the other; they are just different. If you get pro gear, you will pay tons of money to shape the light in just the right way but with some creativity you can DIY it and save a bundle.

**Backgrounds**

Once you have your set all lit up, you may want a backdrop. I have all kinds of different backdrops to choose from when I shoot; some of them were cheap and some cost quite a lot. A popular style of background to use is a muslin. These are a large sheet of fabric that normally

have a tie-dye look to them and you can buy them off the shelf for about $100 or more. If you want to make it yourself, however, you can try your hand at tie-dye work and save money. For this project you will need a large sheet of white or near white fabric, and your best hippie skills. Choose your favorite color set, prep the fabric, boil your dye, and go at it like you're making a shirt. When you are done you have a great backdrop for less than $20. I have heard some reports of making it for under $3, and the results are really very good.

This backdrop is a blue muslin and is about 10' tall x 20' wide and sells for about $180. If you know how to tie dye, you can make your own for around $30.

Another great simple cheap backdrop is to use rolls of white butcher paper. Hang this from the wall or even a stand made of PVC pipe and let the bottom of the paper drape across the floor. Have your models stand on the paper and you end up with one of those cool seamless floor to wall rooms called a cyc wall (cyclorama). While rooms with built-in cyc walls can cost many thousands of dollars, some white seamless paper can do the trick for about 100 bucks or less. A backdrop stand can cost hundreds, but some PVC pipe can work just as well for about a third of the cost.

Here is an example of a setup you can create for about a hundred bucks, right in your living-room. You will need 3 bright lights, some stands, and a background.

For the background get some white butcher paper from a crafts store, or for a few more bucks you can get some white photographic seamless paper. You can hang this either on a background stand or you can tape it to the wall behind you. I like to use some spring clamps to weigh the bottom of the paper down and keep it from curling up at the end, you can buy those for about $2 each on sale, and you will need 4 of them, but you can also tape the paper to the floor.

For the lights, you can use scoop lights, or work lights, The brighter you go the better you can do on your camera's ISO. Or if you have some studio lights or speed-lights you can use those. The key light should be high and to the right with something to soften it just a bit. The fill should be lower in both height and brightness, and should also be softened up. The last light you will want is a background light. Without this your background will look grey. Point this at your white paper, and don't do anything to soften or diffuse this light, you want the light to make a bright spot just behind your subject.

Then place your subjects right on the paper and start shooting. By the time your shoot is over the part of the paper that has been walked on will likely be dirty. That's fine; paper is cheap. Cut off the dirty part and give it to your kids to color on and play with; they will love it. Roll up the rest of the paper for next time.

If you are very budget conscious you can make this example set up, pictured below, for under $100. Or you can spend much more on pro gear and get only slightly better results. Pro gear is better, but unless you are doing pro work or have many thousands of dollars to play with, DIY is usually a great way to go.

DIY solutions are all about using every day ordinary items to accomplish a goal and create uncommon and extraordinary devices. While there are some Rube Goldberg type people out there that are more about the project than the goal, and there really are some complex projects that can be found all over the internet, the key is to keep things as simple as possible. Ask yourself: What do I need to create, and how can I do that for free or at least cheap. There are some great blogs on this subject and one really good one is http://www.diyphotography.net If you find that creating simple solutions to your photographic problems is for you, great. I used DIY stuff for years before buying pro gear. It's not only a great money saver but it can be a lot of fun as well.

# Infrared Photography

Want to break out and get some photos that look a little different from the norm?
Try infrared photography, to captures light that is in the invisible infrared spectrum of light.

### Light Is Radiation

Light is just radiation. It falls on the same electromagnetic spectrum as things like microwaves, gamma rays, x-rays, and radio waves. When we use radio waves to communicate, the length of that wave can be as short as about 1 millimeter to as long as 1000 Kilometers. They are much longer in wave length than visible light. The shortest radio wave is about 1,430 times longer than the longest wave of light, which is 700 nanometers (nm) or 0.0007 millimeters. Our eyes see this wave length as the color red. (Conversely x-rays, the same ones used at the airport to see into your carryon baggage, are about 70,000 times smaller, or shorter than that same color of red.)  Visible light exists from red to violet or about 700 to 400 nanometers. In the grand scheme of things it is a very narrow segment of the total electromagnetic spectrum, but within that small 300nm range, our eyes can perceive every color of the rainbow.

As a side note, most of us humans are trichromats, which is to say that we see in three primary colors and a normal person can see about 100 shades of each, so that is 100^3 giving us a total of about 1 million perceptible colors. Most animals and some partially color-blind people are dichromats, so they can see 100^2 or about ten thousand colors, and there are some lucky women out there that are tetrachromats and can see 4 base colors, so 100^4 or about 100 million

colors all within that 300nm range. There are some animals, mostly birds, out there that can see into the ultraviolet spectrum where the wavelength of light is smaller than 400nm, but for the most part every animal sees only the radiation that falls within that same small 300nm range.

### Cameras detect radiation

Cameras are designed to respond to light much like our eyes do -- by being sensitive to specific wave lengths of radiation. They try to record visible light radiation and ignore all other electromagnetic radiation. In the days of film this was done by finding chemicals that responded to the visible spectrum and embedding those substances in the gelatin layer of the film. Usually that was a silver halide. Today we accomplish this selective radiation vision with filters. Your camera's sensor has a filter bonded to it that removes any light above 700nm (red) and below 400nm (violet). To us this filter looks clear because it allows all of the visible spectrum to pass through it while blocking everything else. So what would happen if that filter were not in place? Your camera's image sensor is actually capable of seeing light from about 200nm (UV) to about 1,200nm (IR). Plenty of unintended radiation would be recorded by your camera and the image would not look as good as it does. So this filter helps your camera see as we see, and thus it produces images that look much like how we see the world.

### IR DSLRs

Infrared cameras, on the other hand, have filters that block the visible spectrum and only let IR light hit the image sensor. I have an old Canon 40D DSLR that was collecting dust, so I sent it to a lab where they removed the old filter and replaced it with one that only lets light at about 720nm and smaller pass through. This conversion is done in a clean room so no dust can get in, and cost about $250. The result of the camera operation is that my camera can now only record IR light and I get some really cool shots.

To clarify, this is not the infrared that the alien in predator has. That IR is often called "thermal vision." For that kind of IR you need a camera capable of far field IR imaging. Far field IR is radiant thermal energy, and cameras for that do exist but they are low resolution and cost a fortune. This type of "heat" IR is in the range of 10,000 to 1,000 pico-meters, way outside of the spectrum of light.

For the type of IR photography we're talking about here, we are still working within the spectrum of light -- in a section called the "near field infrared" or about 700 to 1,400nm. DSLR

sensors, however, stop working at around 1,200 to 1,300nm. The filter I have starts at 720nm and allows in light from there on up, so the real range is 720 to 1,300nm for IR photography, and in that color spectrum of light, you truly are photographing something that cannot be seen with the human eye.

This ability to see the world in a new way can be captivating and it really is a lot of fun. Trees turn bright white, water turns a deep black, pigments and dyes do unexpected things, and the end result is a striking image with impact.

### Some Challenges

With infrared photography you are making your camera do things it was never created to do, and as a result, you will run into some challenges unique to IR photography. I would recommend that you don't try getting into IR photography until you get at least some good control over your camera settings. Once you have that control, IR can be lots of fun. Some of the challenges are autofocus, exposure, lens hot-spotting, and of course, white balance.

Lets start with **autofocus**. DSLR cameras split the light that comes into your viewfinder and direct some of that light to the autofocus sensor. Because lenses refract different wave lengths of light divergently and because lenses are not designed for IR, the light that hits the autofocus sensor may indicate that proper focus is one thing, when in reality it may be slightly different. To overcome this, cameras can be calibrated. If you have your camera converted to IR make sure calibration is included. If you have a particular lens that you know you want to use most of the time with your camera, you may want to send that lens in with your DSLR when the conversion is done. Because each lens is slightly different, most IR cameras will never be perfectly factory sharp when it comes to autofocus. To overcome this you may want to stop down your aperture just a few stops to give you a wider depth of field. Or if your camera allows for micro AF adjustments you will want to do that with each lens you intend to use.

Next is **exposure**. Just like with autofocus, your DSLR camera judges exposure with another sensor that cannot be modified. Visible light is a good indicator of the level of IR light present, so your exposure meter will still work but it will not always be accurate. Depending on the available light your meter may be too low or too high. The only way to know is to take some test shots, and make sure to use exposure bracketing. With just a little extra time this is easy to overcome.

An issue that cannot be easily overcome is lens **hot-spotting**. This is an issue unique to IR photography. Basically a bright overexposed spot can appear right in the middle of your image. This hot spot appears because IR light bounces around inside the lens and collects itself in the middle of the frame and almost like a physical light leak, it fogs the image in a small circle in the middle. This would also happen with normal photography as well, but lenses have a coating inside of them to absorb the extra visible light that would otherwise cause the hot spot. So then what to do? Not all lenses have this problem and if you are shooting IR you may get lucky and just not encounter this issue. Some lenses have a hot spot problem only at some f-stops and not others, while some lenses create hotspots at all f-stops. For the most part hot spots happen at constricted f-stops like f/11 or higher. I have found a few places online where a list of good and poor performing lenses has been aggregated. One such list is at www.kolarivision.com/lenshotspot.html but there are many other lists out there. If you want to do IR I would recommend having a lens that provides minimal hot-spotting.

We have overcome the focus, exposure, and hot spotting. The last big issue with IR photograph is **white balance**. If you shoot with IR film this is not an issue, but I would bet few people shoot like that anymore. For the most part the world has gone digital, so white balance is a matter that we constantly deal with.

Your camera was made to look for color in the range of 400 to 700nm, or colors occurring between 2300K to 10,000K with a specific green/magenta hue. IR is not in that range at all. To compensate, your camera should be set to the custom white balance setting and then be left alone. Unless there is some kind of color drift over time with your camera, there is never a reason to change this setting. Ideally the shop that converts your camera to IR will set the custom setting for you, but in case they didn't or in case you have to reset your camera settings, it is good to know how to do it. The first thing to know is that the colors coming out of your camera will look weird, there is no way around that. The next thing to know is that IR film is also black and white film so IR imagery is traditionally black and white, and it is likely that you will convert your images to black and white in post production so color is not much of an issue. Although with digital there is some color in IR and it can be quite striking, what you want is a white balance that will allow you to record the most dynamic range information to the image file. To get that, it just so happens that calibrating your custom white balance setting using a nice green lawn or something similar to that color works well. From there keep your camera set to the custom setting. If you are using a Canon camera that is the white balance setting with the image

of a flower, for Nikon there is a setting called PRE or PrE in your viewfinder. To set this custom setting consult your owner's manual.

If your custom white balance is done correctly your images will have a strange muted blueish sepia look to them with a bit of magenta and green here and there. Those colors are normal. If your image is bright magenta your white balance is probably off. You can still make a useable image but it will be better if your image is balanced properly.

**Some tips**

Ok now that we have all that science and mechanical stuff out of the way, we can finally talk a bit about actually taking an IR photo. One of the really cool things about IR is that the images look different, and why shouldn't they? After all IR is capturing an entirely different set of colors. Bright white trees, black water, contrast intensive clouds, and crisp clear skies are just some of the fun things IR can do.

I mentioned in the white balance section of IR tips that much of the time infrared is converted to black and white in editing, but you can have some color. With some work you can get a great print that has some features of black and white with some color added in. There are several types of IR cameras but the most common is 720nm. With this type of camera the image starts with a bit of a magenta hue. You can either convert right to black and white or with proper white balancing and camera profiling in your editing software you can get the close to a pure grey scale; however, some things, most notably the sky, will have a sepia tint. You can then use photoshop or a similar program to swap the red and blue color channels and just like that, you have a black and white IR image with a blue sky. This is often called blue sky effect and it really is stunning. Doing a color channel swap is not difficult but each editing program is different. There are many short tutorials on line that will explain this for your specific program, but not all editing programs can do a color channel swap. If you can't make a the channel swap with your software either leave the sky a sepia color, or convert your image to black and white. It will still look great.

## IR Landscapes

*Jason Youn    2013    "Papago at Sunset"*
*40D 720nm IR conversion - 58mm - ISO 400 - f/5 - 1/100th - R/B Chanel Swap*

When I shoot IR I love to shoot landscape. I love the way it gives the world an ethereal feel, like something from a dream. For shooting IR landscapes I shoot them much the same way that I shoot a normal landscape. I like to shoot with a medium to wide-angle lens, I like to play close attention to the rule of thirds, weight and balance, and the other rules of art. But there are a few things I do differently. Because the image will not have the same colors as real life, I try to think about the image as if I were shooting black and white. In a black and white image, contrast not color is the key. Two very different colors may look the same when shot in black and white so color theory no longer applies. But IR is different still, because it can be hard to know what will pop and what won't. There are some things that almost always stand out as bright white, like the green leaves on a tree for example. But some things are a surprise, flowers can do some strange stuff, and that's the great thing about IR. The world looks different.

Another difference with IR is the golden hour rule. 30 minutes before and after sunrise and sunset is great for photographing landscapes and that's also true in IR landscape photography, but because IR works with a different spectrum of light, those hard shadows created by the bright sun can actually work to your advantage. With IR photography, shooting in midday is not always

such a bad thing. The golden hour rule still applies to a point, but midday shooting can also work very well.

Though digital has all but eliminated the need for filters, one that is still popular is a UV-haze filter. This type of filter removes much of the UV light in the atmosphere. Though most of the time people use these to protect their lens, the real reason they were invented is because we have dust in the sky. The dust and particulates that float around the atmosphere are struck by the light of the sun, and it just so happens that they are the perfect size to let most visible light through and still manage to scatter much of the ultraviolet light. That scattered UV light combined with some scattered visible light limits the distance that we can see. Infrared, however, has a longer wave length and cuts through the haze with ease. The result is that IR photos can often capture an image of something that is much farther off and otherwise obscured by haze. This next example is of two photos that were given to me courtesy of www.Kolarivision.com. (Kolari also did a great job with my camera's 720nm conversion.) Each photo is more or less the same but the first is a regular digital photograph and the second is an IR image. I want you to notice a few things. First, notice how the scene in the regular photograph fades off into the fog while the IR can see

right through it? If you have a color eReader, also notice how the trees in IR version turn a whitish cyan/blue and the sky has a sepia color to it. This is the camera trying to make sense of the near field IR colors that it is collecting. Both the normal image and the IR image are fairly unedited so that you can see how the image comes out of the camera.

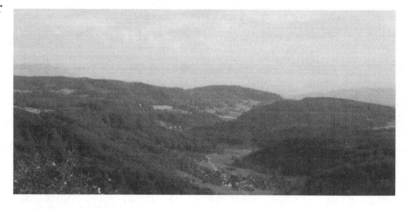

In the second image above we can see much farther into the distance because the infrared light is not as easily disrupted by dust in the atmosphere.

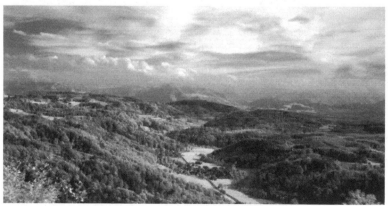

The next image shows the same landscape scene again with the red blue channel swap.

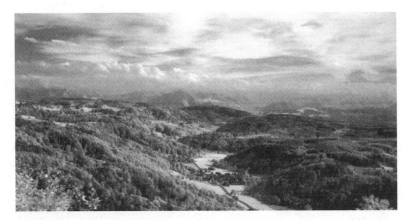

Next we again see the same scene with the trees desaturated so they look more black and white. This can either be accomplished with good white balancing while you edit, or by manipulating each color channel individually when you edit.

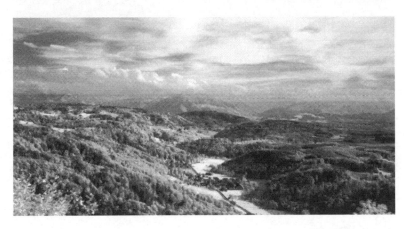

I know I have talked a bit about editing in this IR section, and while this book is not about editing, but rather the camera work itself, IR is one case where we really cannot address one without addressing the other. If any of the editing techniques that are mentioned sound difficult, don't be discouraged. With a little practice they will come naturally.

While landscape is probably one of the best subjects to shoot with infrared, it is, of course, not the only thing out there. Photographing people with IR can yield some very interesting results. Hair can look fake, skin can look plastic like from a doll, and when converted to black and white it can give your images a very unique feel. One fun thing about infrared and human skin is that it penetrates deeper into our skin than visible light. As a result you can take a freshly shaven man out into bright daylight and make a portrait, but he will look just like he has a five o' clock shadow. I mentioned earlier that dyed fabric can look strange. Black suits are really interesting. Though it can look like the pants and jacket are the same color black to us, an IR camera may see it as several shades of grey and even white.

Infrared photography is a lot of fun, and I hope you get the chance to play with it sometime. If you are still trying to get the hang of your camera, however, you may want to wait. It can be a bit challenging, but if you think it looks interesting, go for it. It's worth the time and effort.

**Infrared photography recap:**

•Use the rules of art, balance, thirds.

•Things will look different.

•This is not thermal vision.

•Trees are normally bright.

•Water is normally dark.

•Shoot in RAW mode.

•Shoot with custom W/B.

•Bracket for exposure, your meter may be inaccurate.

•Autofocus may be out of calibration.

•Find a lens that does not hot spot.

•Hot spots can be more common at higher f-stops.

•Spend some time editing.

•Have fun.

# Final Thoughts

Over the years, photography has brought me great joy. It has encouraged me to look at the world through different lenses. It has enticed me to go to places I would not have otherwise gone. I'm not a morning person, but you have to get up early to capture that morning light. Without that prod, I would have just stayed in bed, or my sleeping bag, and I would have missed some of the most beautiful views the world has to offer. I owe a lot to my cameras, and I have learned a lot from them. But to learn anything from them, I first had to learn how to use them. Using a camera is both a science and an art, left brain and right, and it's mentally and physically taxing. At the end of a long wedding, both my body and mind are exhausted. After a big shoot, I wait a few days and then review the photos on my computer. It is a lot like opening a gift: "What did I get?" But none of the stunning images in my portfolio would have been possible without tens of thousands of really bad ones. Even today, I will shoot a wedding and capture 3,000 or so shots. I only deliver about 300. Thats a 10 to 1 shot ratio. I'm not saying that the other 9 are bad. Many times I have 5 versions of the same shot, and only one is best. So the others get shelved. Ansel Adams said, "Twelve significant photographs in one year is a good crop." I think twelve is setting the bar a bit high, but his point remains, you have to take a lot of bad images to get a worthwhile photo. After many junk photographs you may make a good one and even then most good ones will never be great. My first photographs were simply terrible.

What is it, though, that Ansel Adams had that made his photographs significant? What makes an image great? Certainly the rules of art and the science of a camera must work together to make a great image, but what about those great photos that break all the rules? How can those be great as well? A photograph can be well lit, well composed, well shot -- everything about it can be perfect, but if it does not *impact* the viewer, it's worthless. Those photographs that by every other standard should be junk, yet everyone seems to love, have impact. The rules of photography and art can help you create impact, but only *you* can really make it happen. I can tell you from experience: The photos that "have it" are not always the ones you think will be great when you click the shutter. Occasionally, it's those shots you initially disregarded that end up being the best.

Sometimes, I still pull out those old photos that I took as a child. My parents were generous with their film budget, and there is truly not a decent photograph anywhere in the mix. They would impact no one other than the nostalgic side of my own personality. But I enjoyed shooting. I still remember that sound -- a combination of a click and ping as the cheap spring opened and then closed the plastic shutter, followed by the zipper-like winding noise as my thumb hastily advanced the reel to the next frame so that I could blow yet another shot. It was one of the many sounds of summer. It was fun. In the following years, I would graduate to a 35mm SLR and shoot black and white film for classes, fun, and sometimes for family members who wanted portraits. My point? I have taken more bad photographs than most people will shoot in their entire lives.

Don't be afraid to burn through frames and keep that shutter moving; don't be afraid to shoot junk images. You paid a lot of money for your camera, and its shutter is good for at least 100,000 shots, and in some cases, much more. I encourage you to wear your camera out. But don't just shoot for the sake of shooting. Keep the science of the camera in your mind as you work. Your camera has a setting to auto display a preview image after each shot. Turn it on. Check the preview screen on your camera often. If you don't like something about your photo, ask yourself, "What caused this?" Is it a composition problem or a technical one?

Get a good handle on reciprocity, depth of field, color balance, and lighting. These things just take practice. If you don't have a tripod, get one. Remember that the science and the camera gear are just half the equation. Keep the rules of art in mind. Remember the rule of thirds, leading looks, balance, leading lines, and backgrounds. Working both sides of the brain like this can be hard and it can wear you out, but it's worth it.

One of the most important things you can do as a photographer is to find a hero. I don't mean Bat Man, though I'm sure he has some cool toys to play with. I mean find some other photographer whose work you identify with. Their work should have an impact on you. I have several, and not all of them are photographers. I love the Dutch master painters and I often try to use their examples of light in my work. It's a challenge to make light look that good, but it's not impossible. Who is your hero? You can see my work at www.JasonYoun.com. I'm not saying I need to be your hero. But I can't write this entire book and not plug my work just once. For inspiration I like to visit www.lightstalking.com which is a great photo blog. If you want to focus more on the gear side of things and less the image and style, http://petapixel.com is a great photo blog. Recently I have been following the work of photographer Ian Ruhter http://

www.ianruhter.com The people at http://www.teoe.org are always interesting. Chadwick Fowler http://www.chadwickfowler.com is a local Phoenix area photographer with some edgy lighting. Patrick Madigan http://www.patrickmadigan.com has some cool dark takes on the Arizona wilderness. Garry Ladd http://www.garyladdphotography.com is one of the hot names in landscape, and recently portrait photography. Gregory Colbert has some incredible photos from around the world https://gregorycolbert.com and Hollye Schumacher http://www.hollye.com has some really great wedding and dog photography. I would encourage you to follow several photographers, and look at as many images as you can. As you look you will hone, adapt, and evolve your photography skills and styles.

Years ago, I earned a pilot's license. Right after my check ride an old pilot named Roy came up to me and congratulated me. Roy has tens of thousands of hours in the sky and in 2004 he was inducted into the hall of fame at the Pima Air & Space Museum in Tucson, Arizona, for his contributions to aviation. He is literally a living legend, so his words bear a certain weight. He said one thing that has stuck with me: "Now you have a license to learn."

Just like flying, photography is a life-long learning experience. Never stop learning new things or trying new techniques. Most of all, keep shooting.

Thank you for reading this photography guide. Growing up I was a very bad speller and struggled with mild dyslexia. I am quite sure that my elementary school teachers would be in shock to discover that I would ever write anything, let alone a book, so it brings me great joy that you took your time to read my work.

Thank you,

*Jason Youn*

## Please take a moment and review this book online :)

If you have any questions please feel free to email me directly.

My contact information can be found at www.JasonYoun.com

# This book references these people, books, blogs, and organizations:

**View from the Window at Le Gras (*La cour du domaine du Gras*)**

http://en.wikipedia.org/wiki/View_from_the_Window_at_Le_Gras

**Chase Jarvis -** *The Best Camera Is The One That's With You*

http://amzn.com/0321684788

**The Library of Congress**

http://www.loc.gov

**Alfred Hitchcock**

http://en.wikipedia.org/wiki/Alfred_Hitchcock

**Mark Rothko**

http://en.wikipedia.org/wiki/Mark_Rothko

**Through Each Others Eyes**

http://www.teoe.org

**Arizona Highways Magazine**

http://www.arizhwys.com

**DIY Photography**

http://www.diyphotography.net

**Kolari Vision**

http://www.kolarivision.com

**LightStalking**

http://www.lightstalking.com

**PetaPixel**

http://petapixel.com

**Ian Ruhter**

http://www.ianruhter.com

**Chadwick Fowler**

http://www.chadwickfowler.com

**Patrick Madigan**

http://www.patrickmadigan.com

**Garry Ladd**

http://www.garyladdphotography.com

**Gregory Colbert**

https://gregorycolbert.com

**Hollye Schumacher**

http://www.hollye.com

**Roy Coulliette of Turf Soaring School**

http://turf-soaring.com

**Jason Youn**

http://JasonYoun.com

Made in the USA
Lexington, KY
17 July 2015